GUY
MARTIN

THE
PARALLEL
STATE

GOST

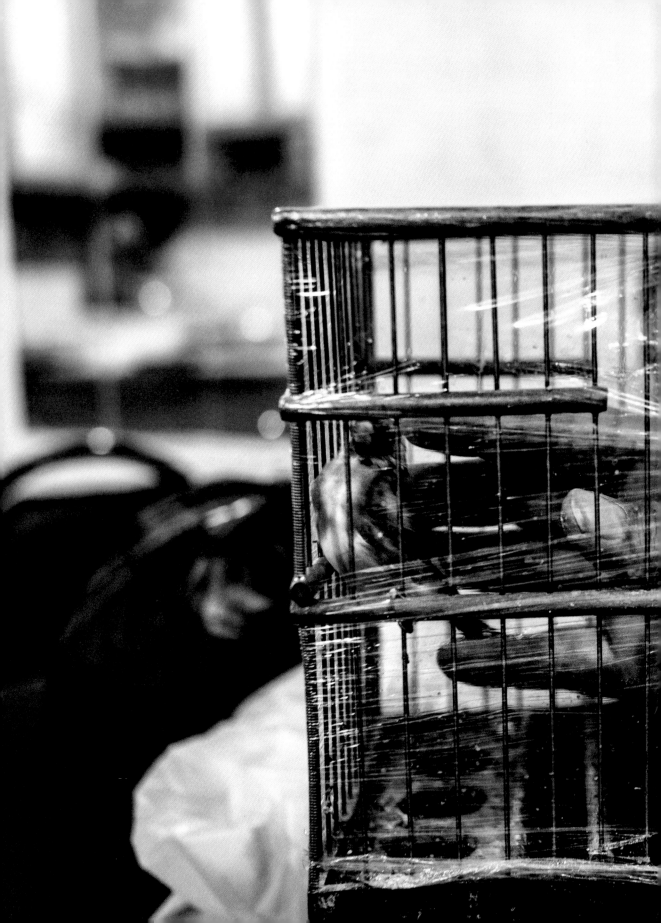

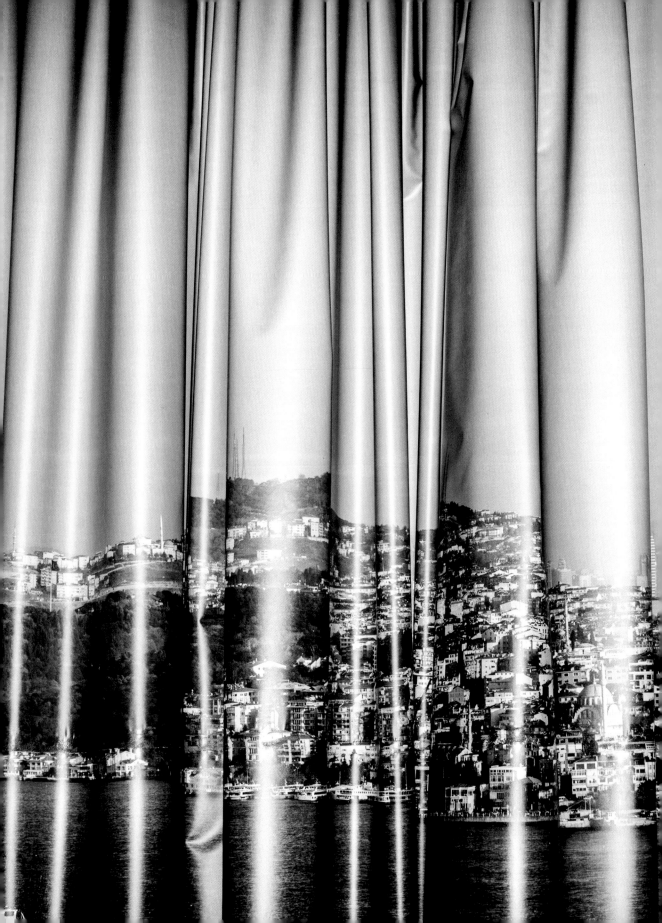

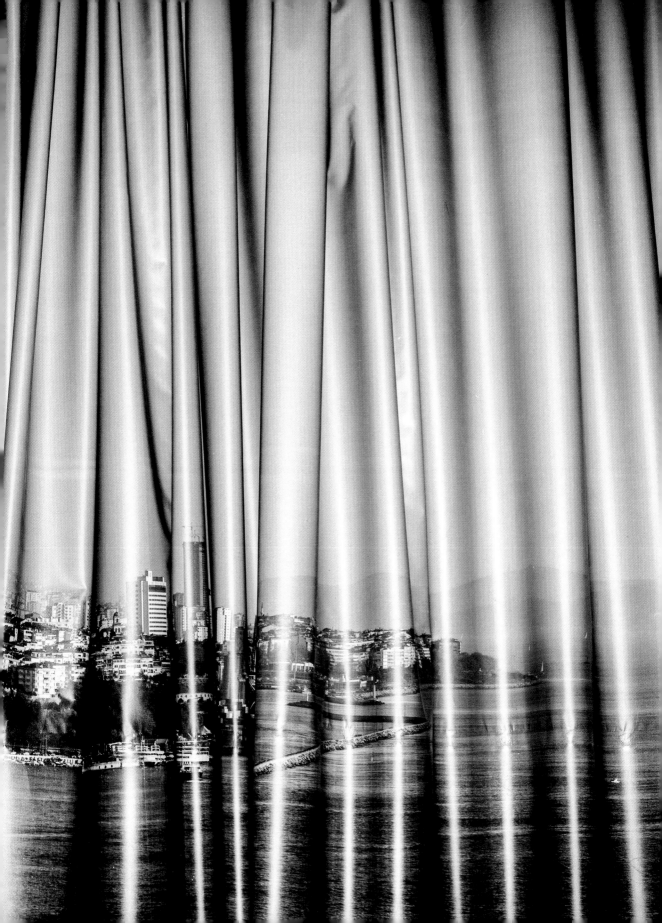

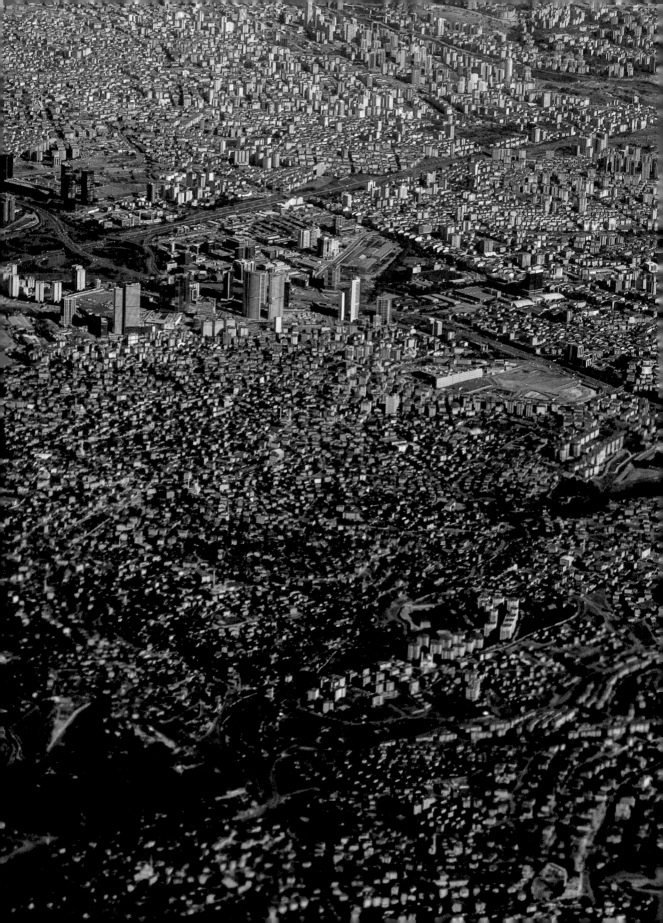

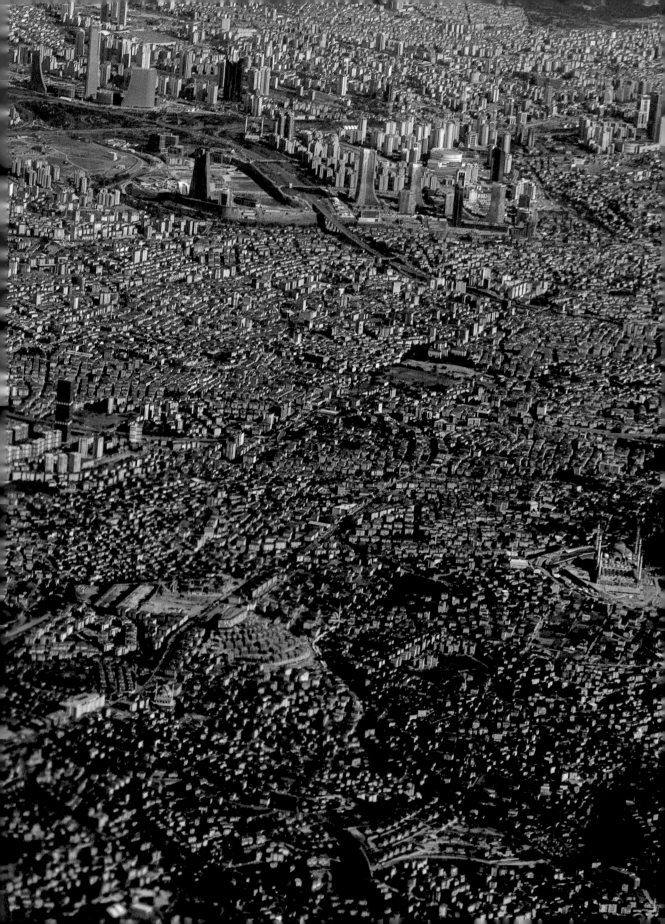

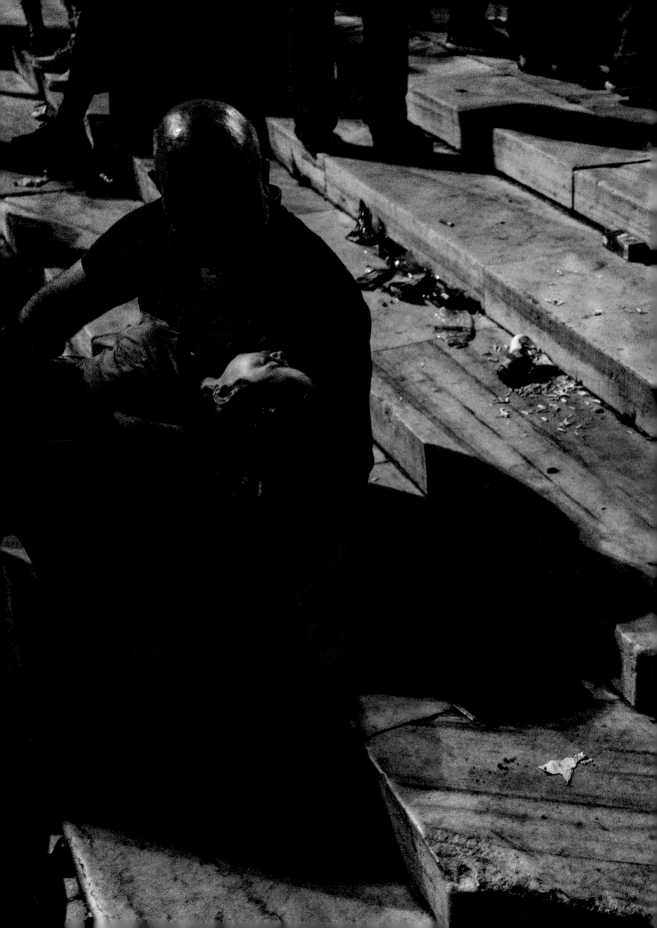

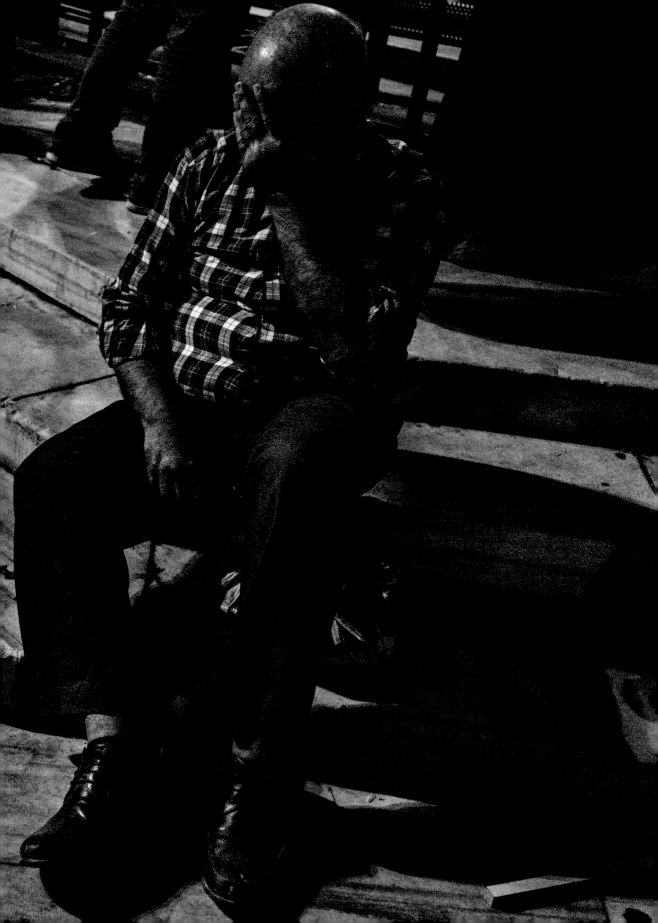

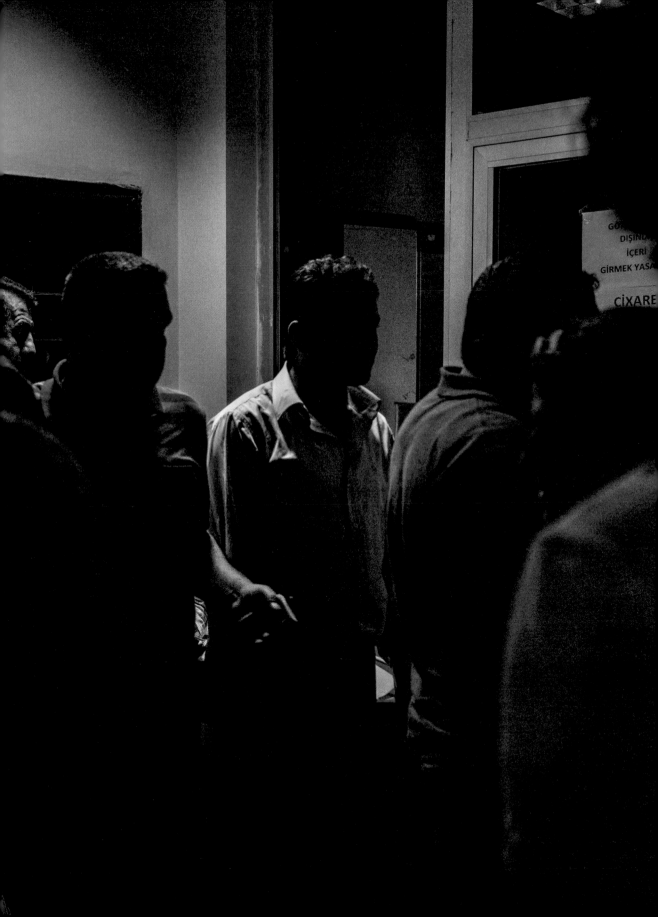

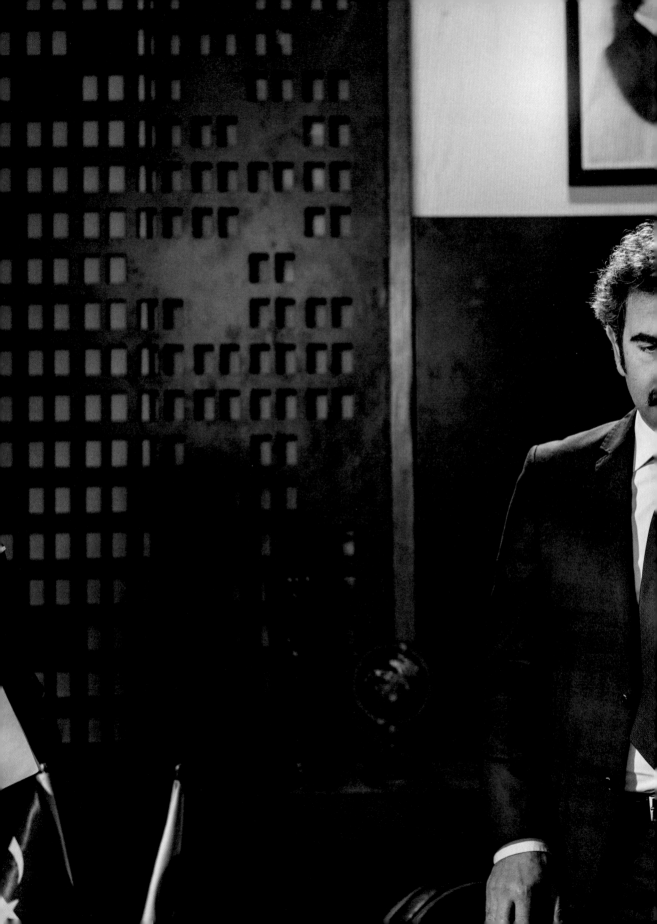

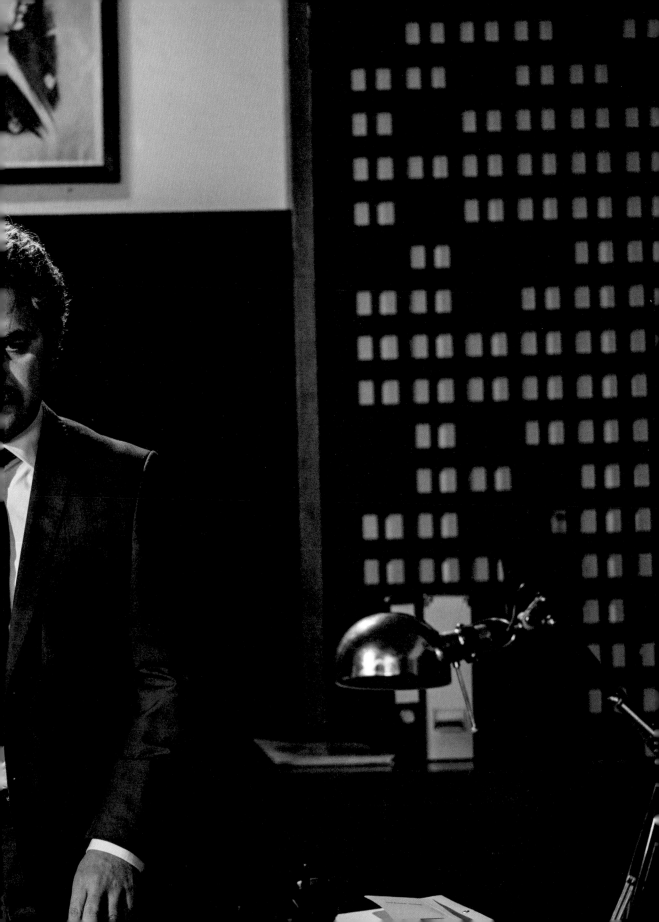

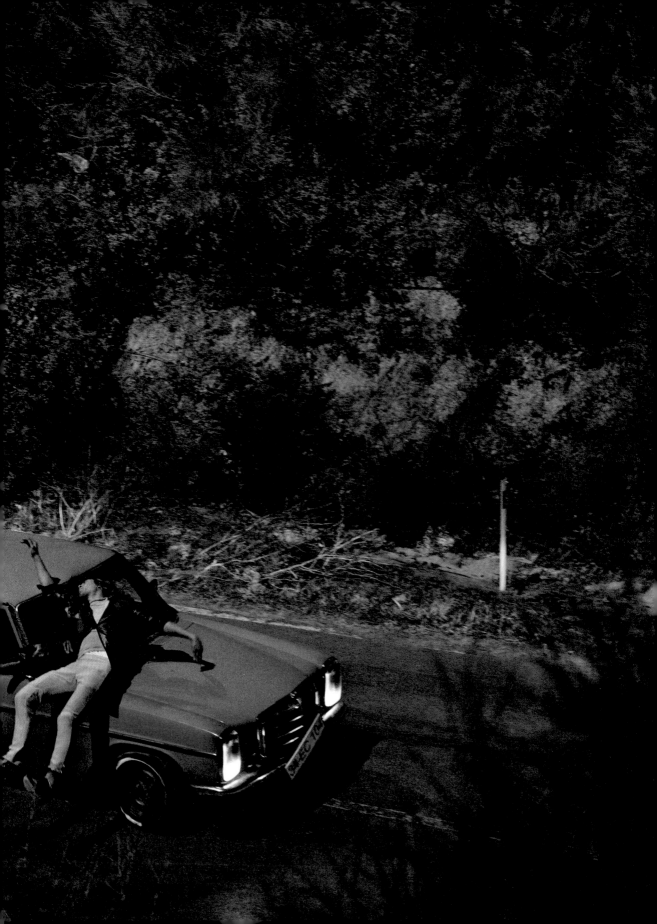

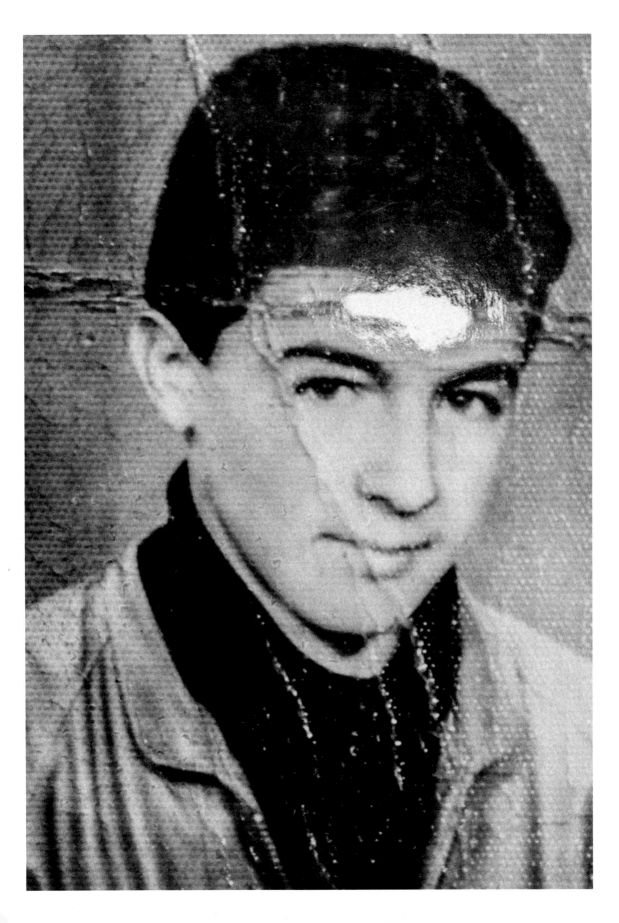

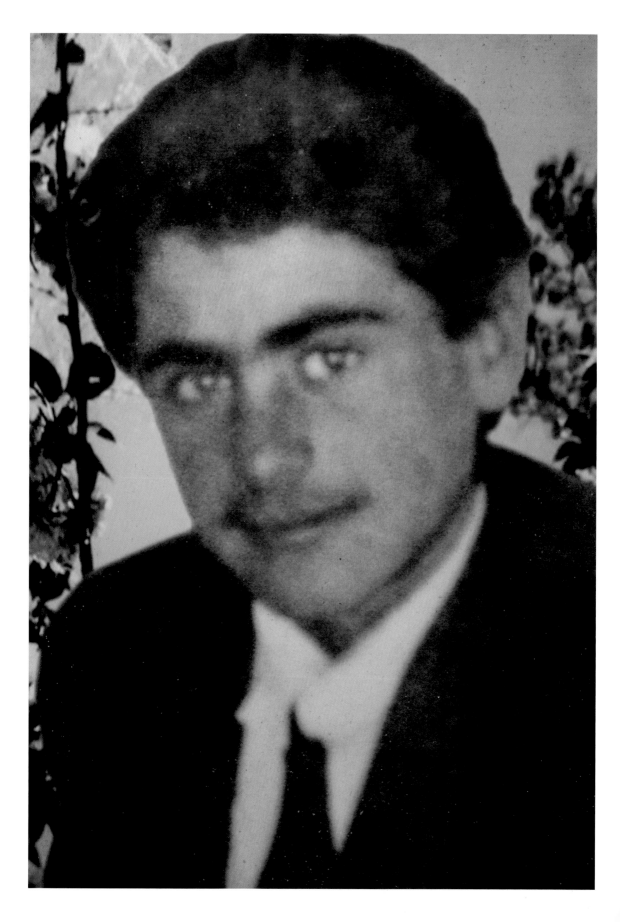

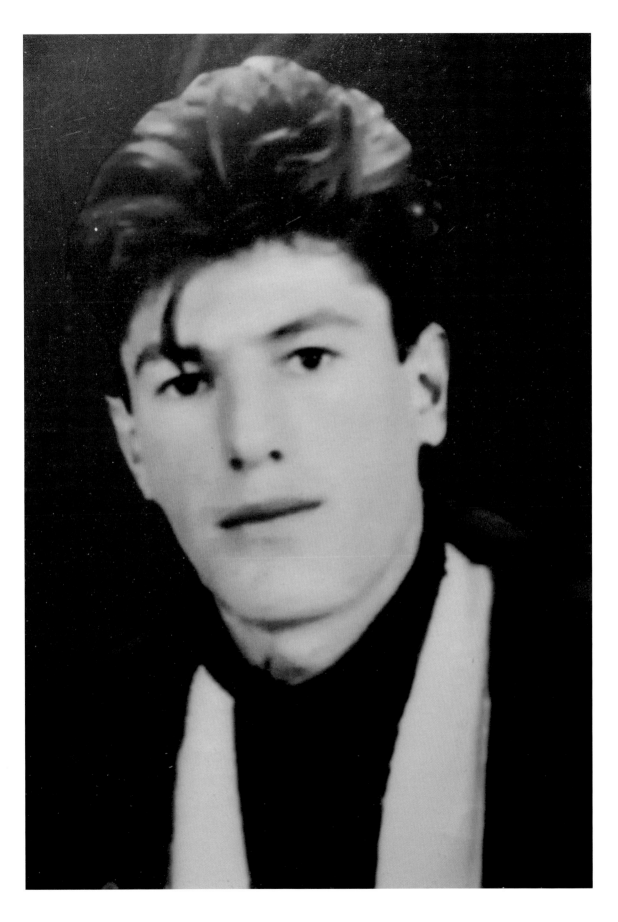

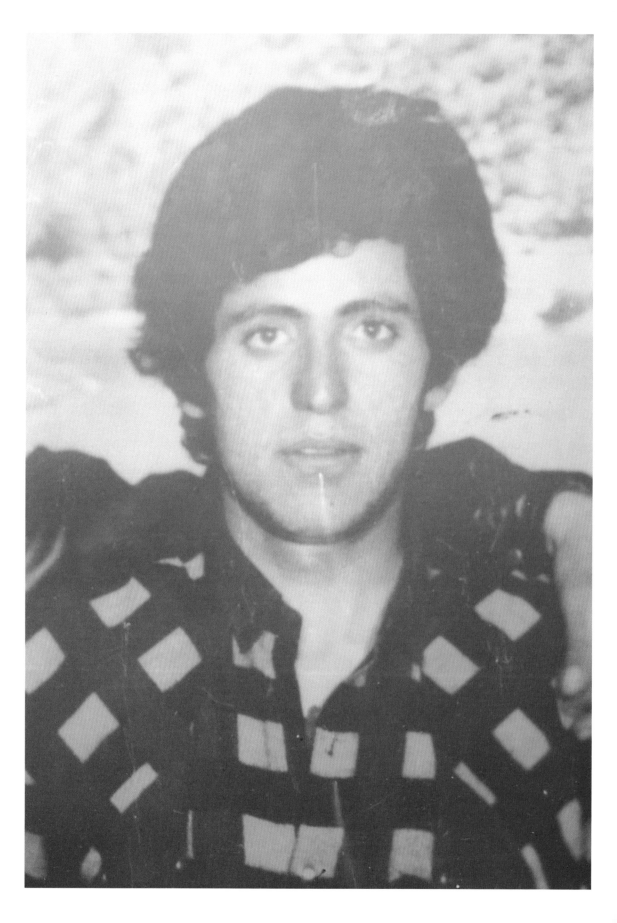

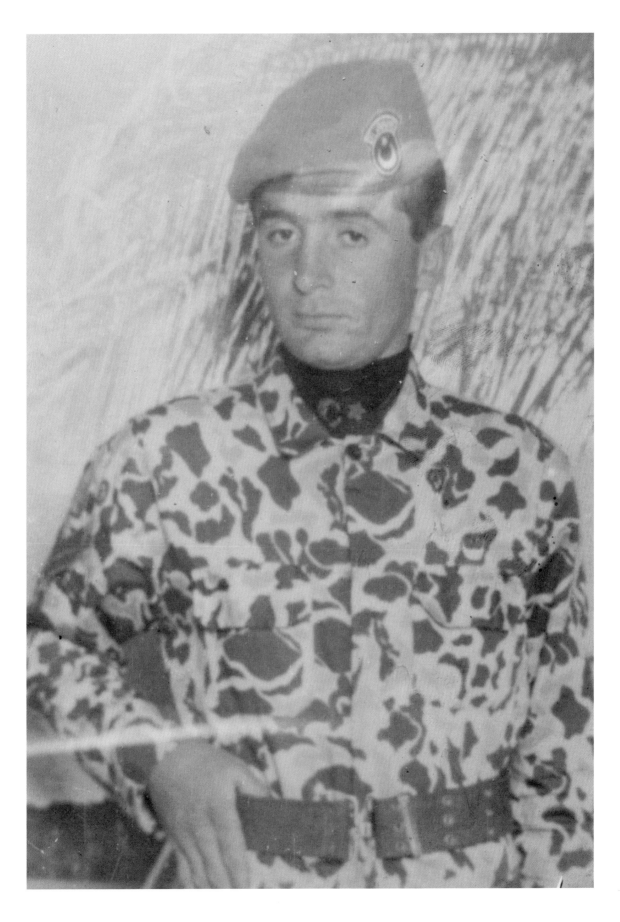

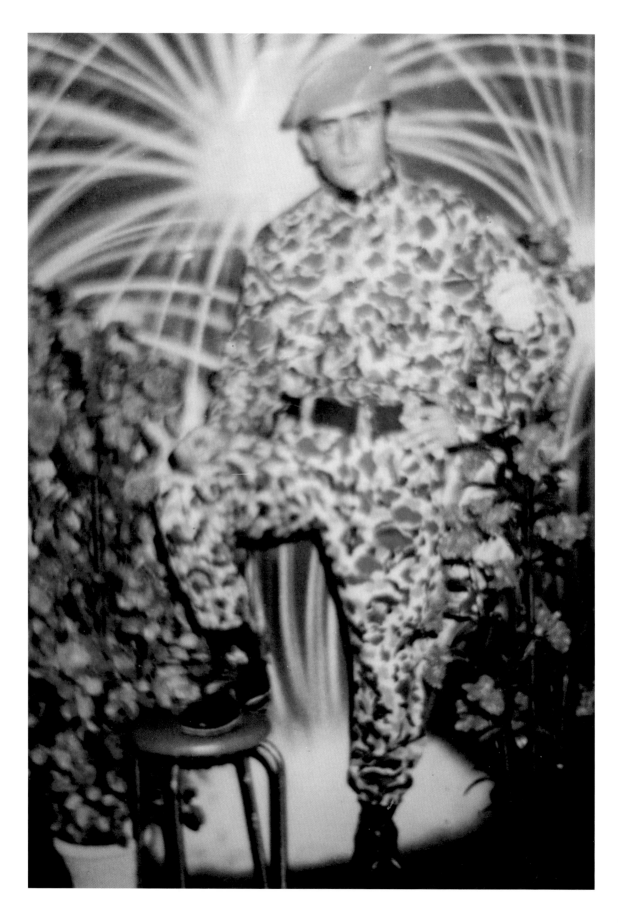

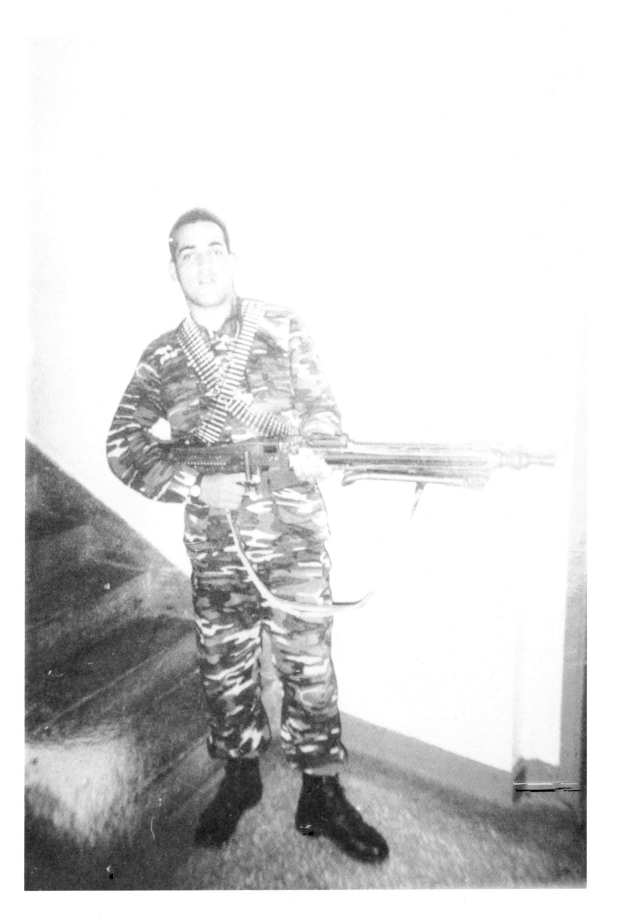

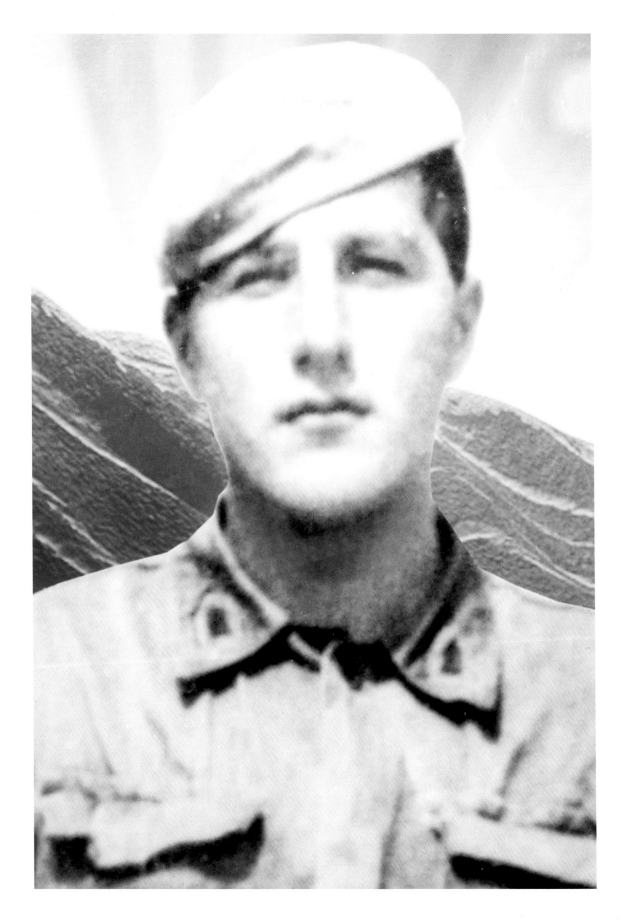

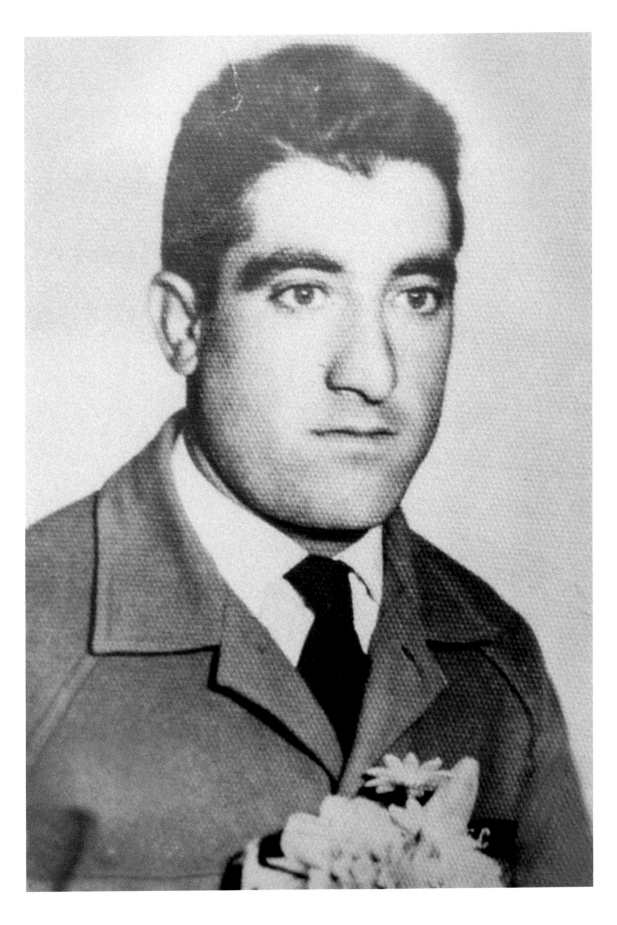

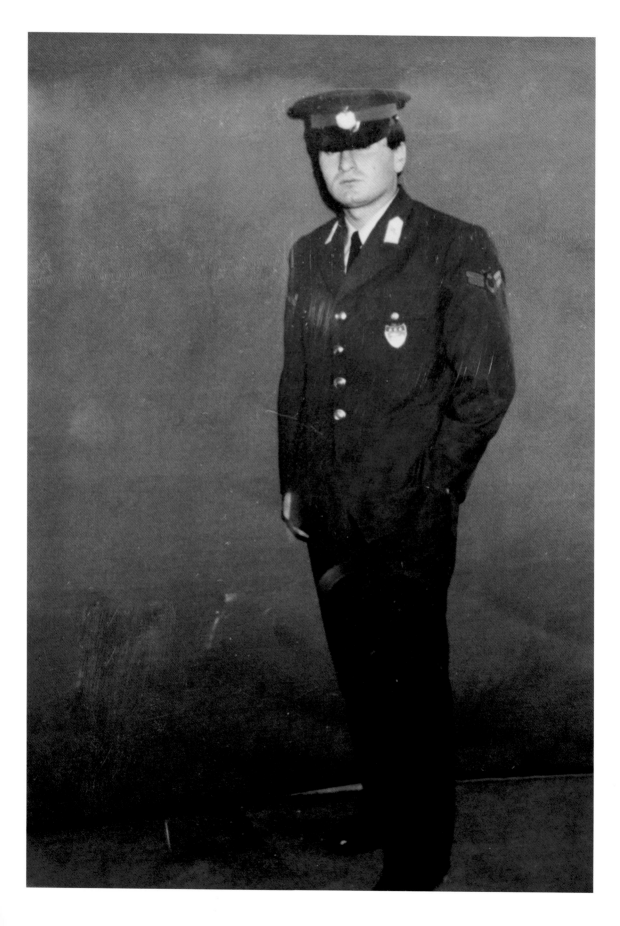

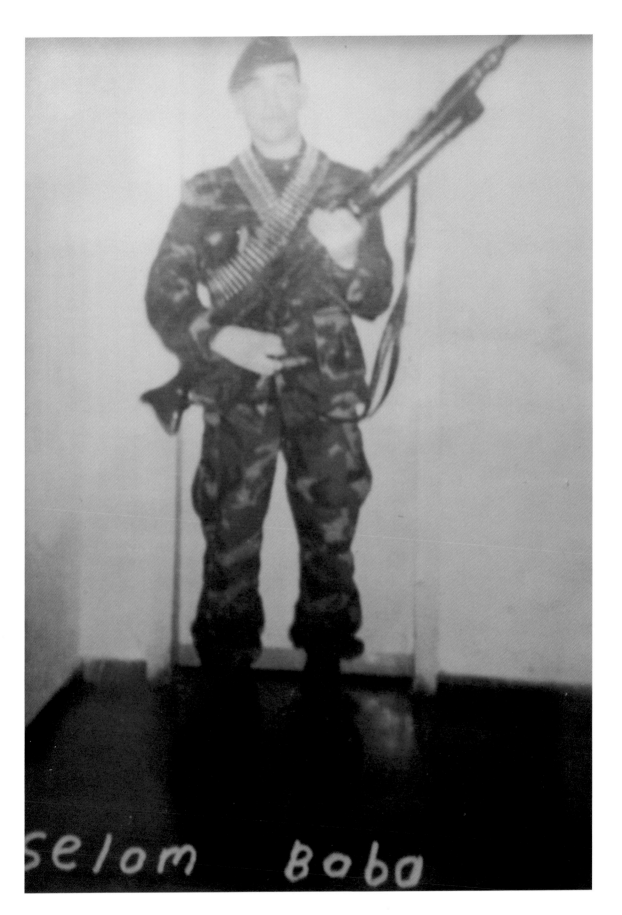

Selom Boba

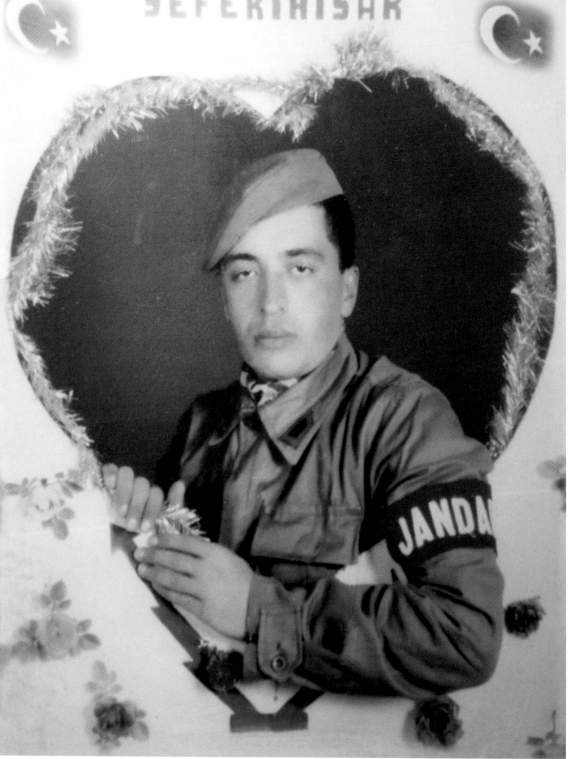

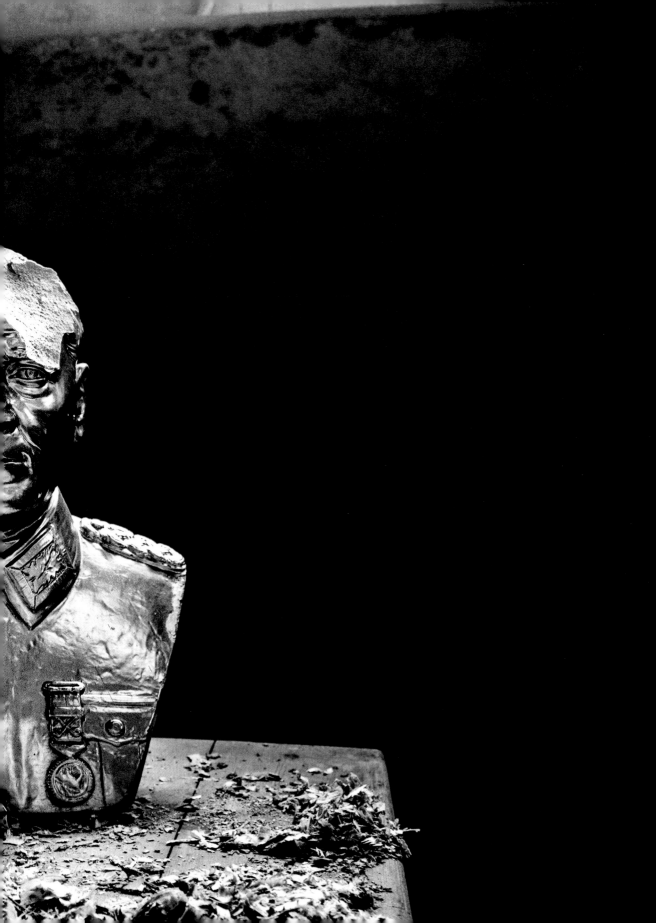

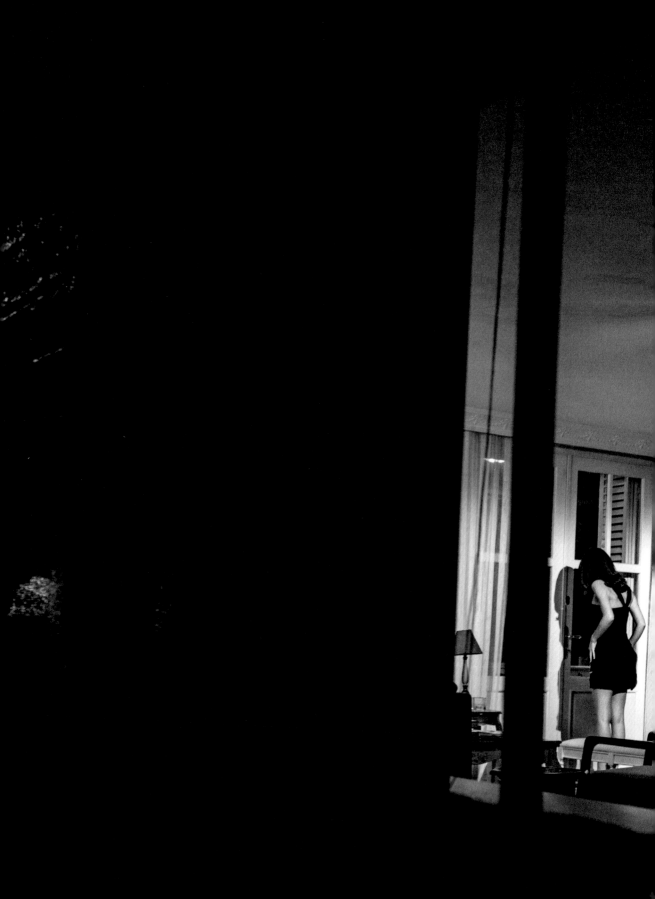

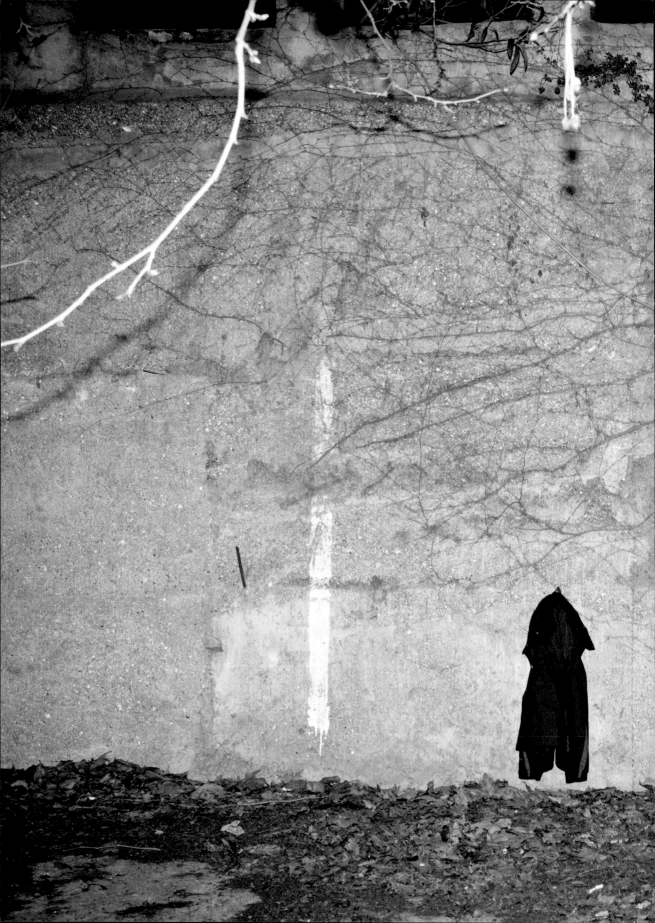

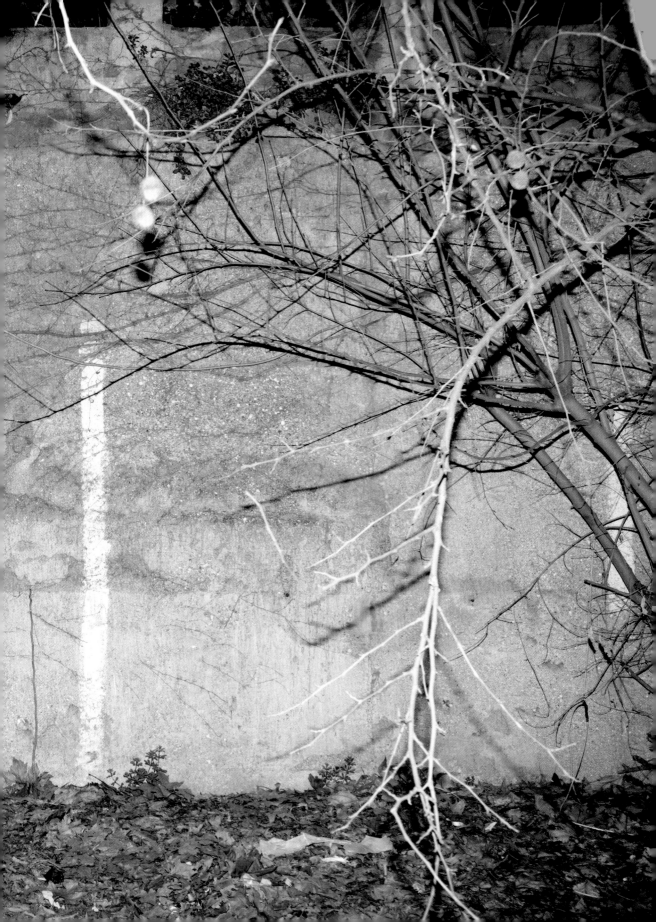

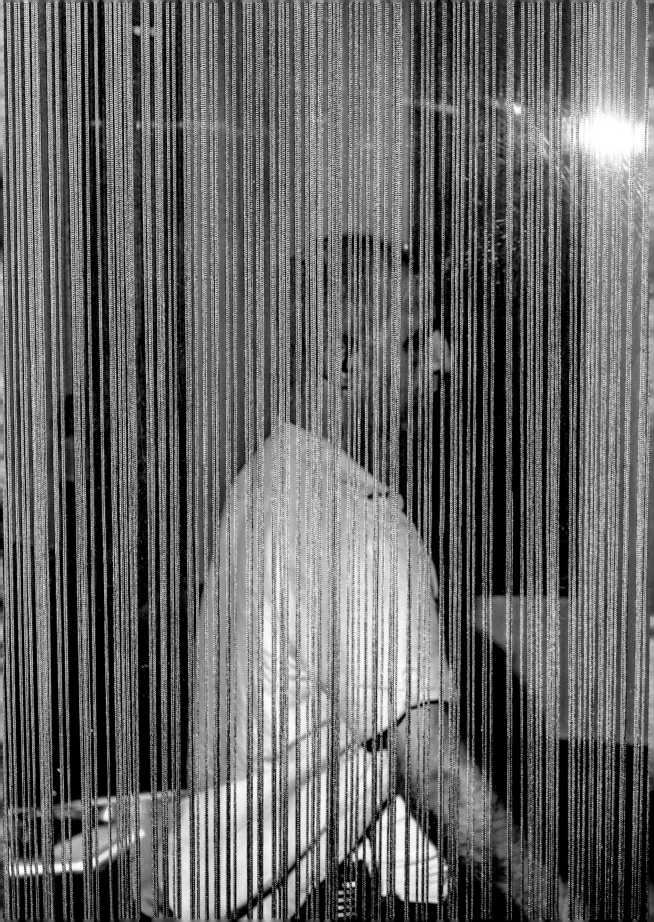

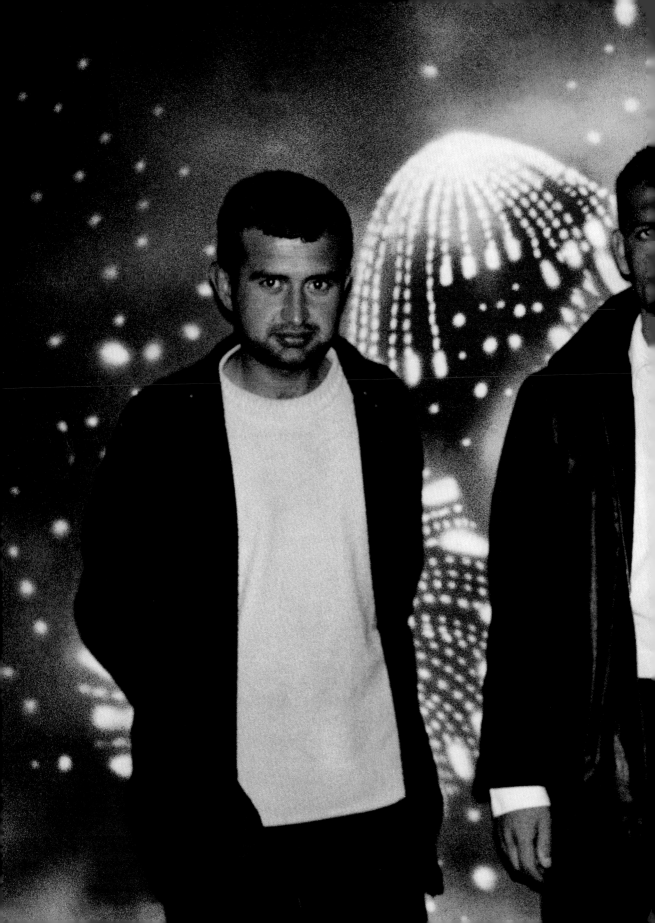

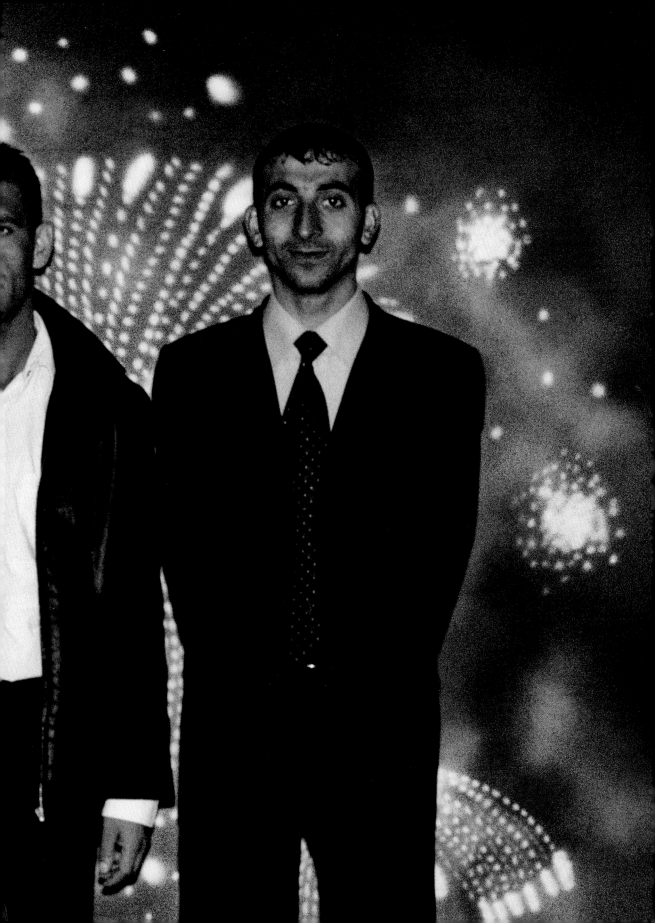

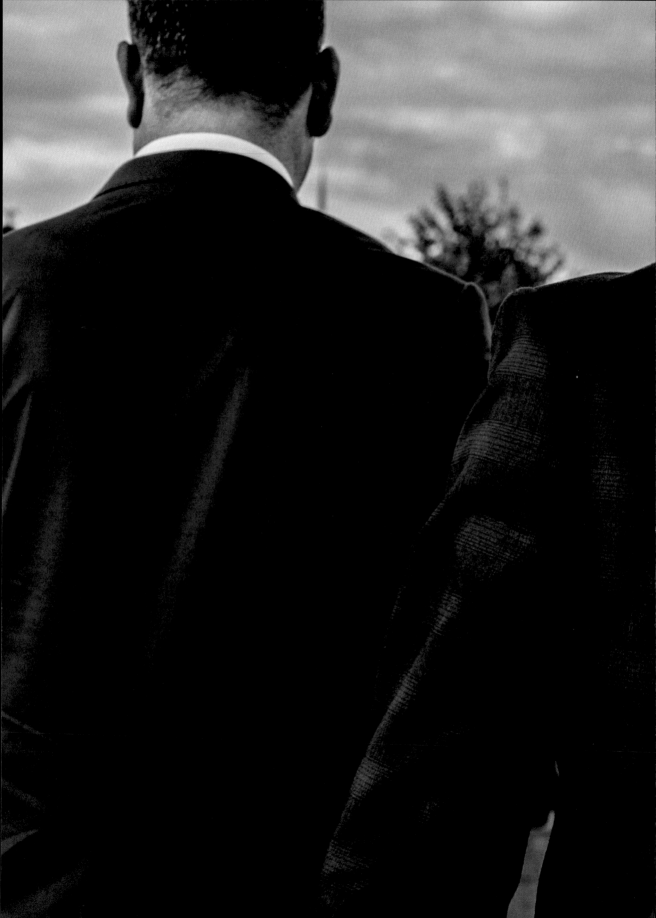

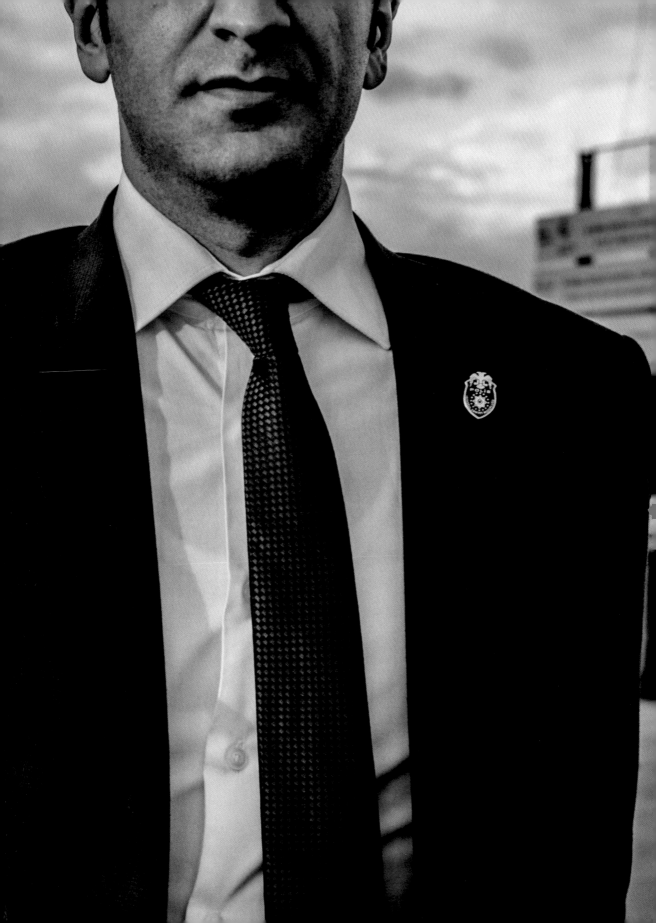

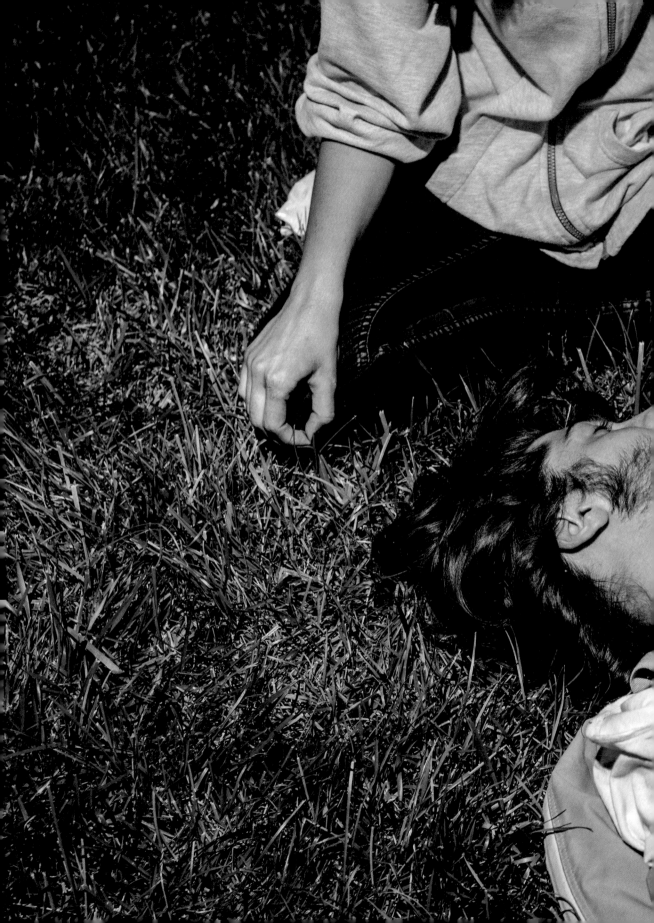

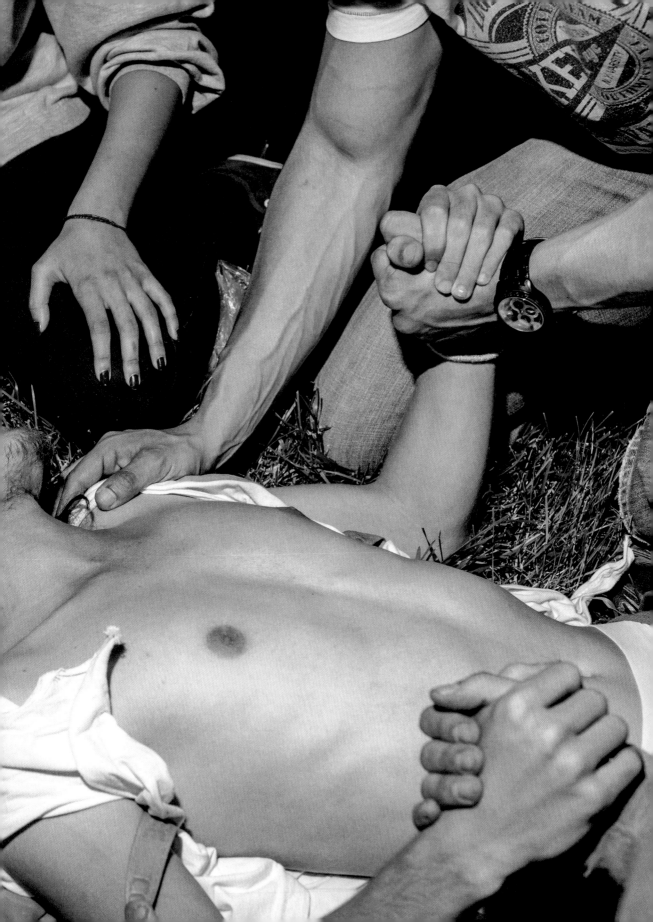

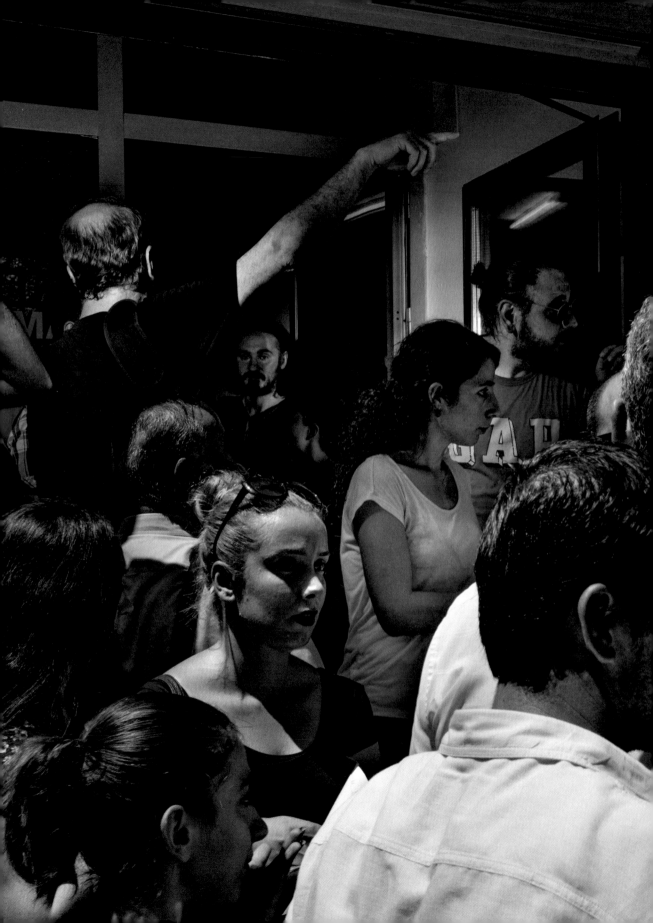

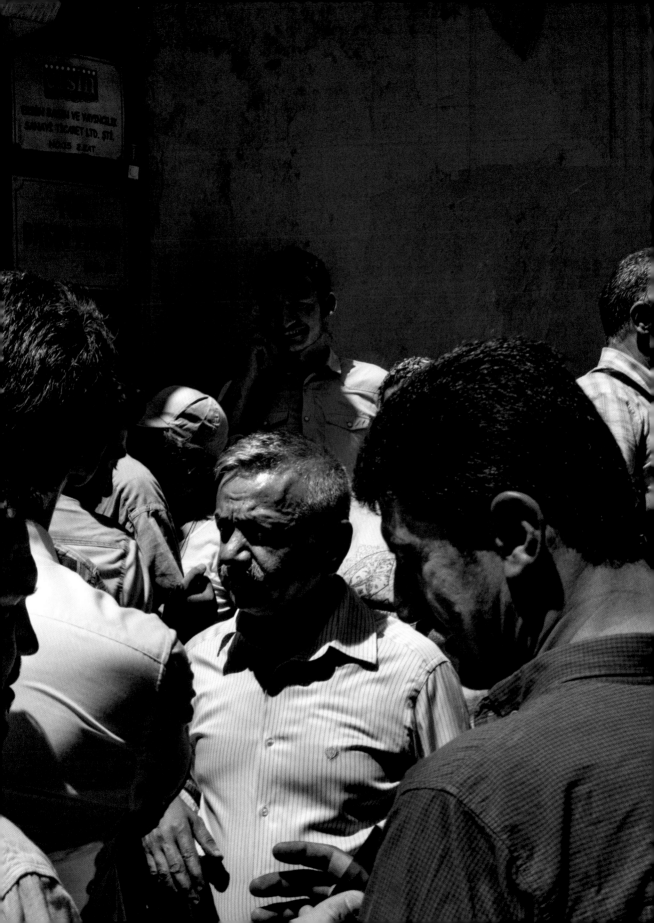

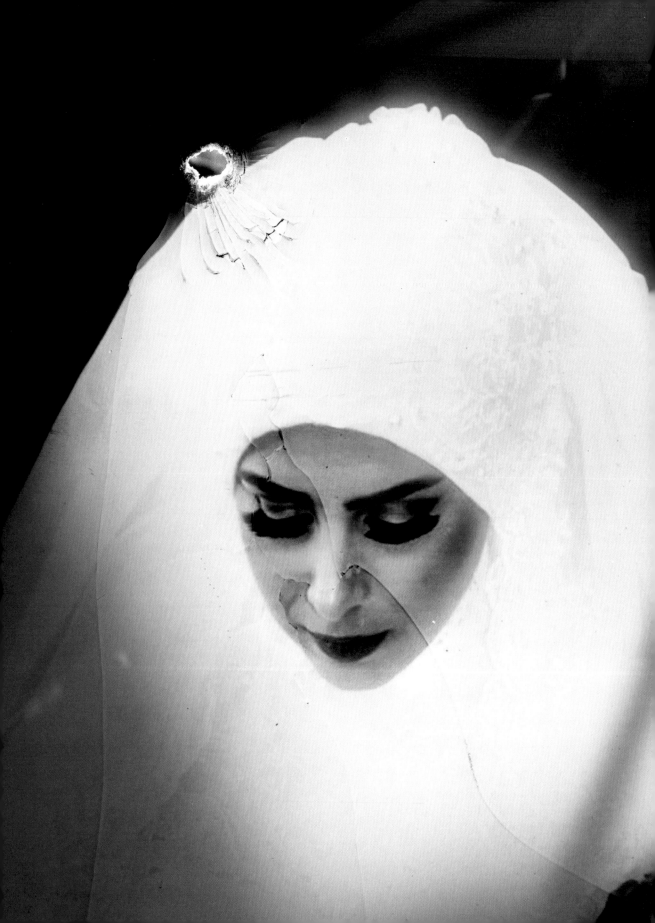

A group of plotters from the failed Turkish coup on the night of 15 July 2016 used a WhatsApp group to communicate with each other. This transcript is part of a Bellingcat.com open source analysis of the group conversation, which includes information of the persons and military units involved. All times mentioned are GMT plus 3hrs.

Maj. Çelebioğlu created the group "Yurtta sulh".

Maj. Çelebioğlu added you.

Maj. Çelebioğlu added Col. Kaya to the group.

Maj. Çelebioğlu 21:15
I'm Maj. Çelebioğlu. I'll be making public announcements from here.
[phone number] 21:16
All right.
Maj. Akkaya 21:17
Ok.
Maj. Çelebioğlu 21:17
You can provide important updates here. I'll pass them on to Ankara.
Lt. Özgenç 21:17
Ok.
[phone number] 21:18
Ok.

Maj. Çelebioğlu added Col. Şahin.

Maj. Çelebioğlu added Murat Karakaş.

Maj. Özleblebici 21:18
Do not respond to every message, just listen… it is causing too much of a distraction.

Maj. Çelebioğlu added Maj. Yanık.

[phone number] 21:18
Ok.
Maj. Çelebioğlu 21:26
Brig. Özkan Aydoğdu [phone number]
The traffic on the E5 and TEM [Trans European Motorway] outside of Istanbul will be left as it is. Traffic trying to enter Istanbul will be halted and turned back.
Col. Gerehan 21:28
That which needs to be taken must be taken immediately…
Col. Kaya 21:29
6th started
Maj. Çelebioğlu 21:29
Col. Zeki [Gerehan], are you at the academy? Fatih Irmak needs support.

Maj. Çelebioğlu 21:30
He cannot convince his unit. Zafer Özleblebçi are you at the academy?
Col. Gerehan 21:31
Ok, we are on our way to help.
[phone number] 21:32
Does the same apply to the bridges Murat Entry—exit?
Col. Gerehan 21:32
Fatih, come to the stop at the main entrance of the barracks.
Maj. Yanık 21:32
Fatih and his team are onboard. There's no problem.
Col. Gerehan 21:33
Ok we continue as normal.
Maj. Çelebioğlu 21:33
Commander, it is my personal opinion that they should go to their homes.
[phone number] 21:33
Ok.
Maj. Çelebioğlu 21:34
Are 2nd and 66th having difficulties due to traffic congestion on the roads?
Maj. Akkaya 21:34
We have not left yet.
Maj. Çelebioğlu 21:35
Colonel Muammer [Aygar], 2nd and 66th, location?
Col. Kaya 21:35
6th Regiment has left and is about to reach AKOM.
Maj. Çelebioğlu 21:35
…we had thought they'd be sent back home after having taking up positions.

Maj. Çelebioğlu added Lt.-Col. Düzenli.

Maj. Çelebioğlu added phone number.

Maj. Çelebioğlu added phone number.

Maj. Yanık 21:43
Fatih situation: positive? negative?
Col. Kaya 21:45
Intervention at AKOM. It is being interned. Personnel are following our orders. Shortly the situation will be under control.
Maj. Aygar 21:45
Access to the First Bridge from the European side has been halted. 1. Bridge direction to Europe has been halted. The police point on the 2nd bridge has been reached. No problems.
Col. Gerehan 21:50
Who should the Hadimköy reinforcements contact, the contact that has agreed upon is not there They are waiting at the the entrance.
Col. Kaya 21:53
TRT Radio on the road.

Maj. Çelebioğlu 21:54
We are calling Eyüp Pasha Who has Mehmet Erol's phone number?
Maj. Yanık 21:55
Eyüp has been contacted. He will get the gates open and is speaking to Mehmet Erol.
Col. Cebeci 21:55
[mobile phone number]
Maj. Yanık 21:56
HAK K [Harp Akademisi Komutanlığı] has been taken. Follow Hadimköy units.
Col. Kaya 21:56
AKOM has been seized. They are urgently requesting help from the technical team of the Air Force to cut off broadcasting. They are trying themselves but are unable to do it.
Maj. Aygar 21:57
Police are following orders at the 2nd Bridge, no problems.
Col. Kaya 21:57
(Mustafa Kubilay's contact details shared.) Please share, call for support from the technical team to cut off broadcasting.
Lt.-Col. Çoşkun 21:58
[Unknown]
Col. Kaya 22:02
TRT TV is on its way.
Lt. Özgenc 22:04
Bayrampaşa is on its way. Airport is on its way.
Maj. Çelebioğlu 22:06
The deputies of the Istanbul police chief have been called, informed, and the vast majority have complied.
Col. Şahin 22:06
The deputies of Istanbul police have complied. Tell our police friends: I kiss their eyes.
Col. Kaya 22:06
LDÜ is on its way.
Col. Cebeci 22:09
The job of apprehending the 1st Army Commander immediately.

Maj. Çelebioğlu added Lt.-Col. (Air) Erol.

Maj. Çelebioğlu 22:11
Is Hadimköy ready, they are asking from Ankara.
Col. Cebeci
Please take the army commander. For what is happening
Col. Gerehan 22:12
Academy reinforcement unit is at Hadimköy.
Lt.-Col. Çoşkun 22:12
Hadimköy is ready.
Maj. Çelebioğlu 22:16
Murat Çoban's phone number?

Maj. Çelebioğlu added phone number.

Col. Cebeci 22:16
Destination is General Kani
Akman 1. Garrison in Hadımköy.

Maj. Aygar 22:17
For info. 1st Army Commander keeps
calling Kulekli Commander.

Col. Gerehan 22:18
Hadımköy was going to send location?

Col. Şahin
Mürsel, don't answer the phones.

Col. Cebeci 22:19
Two locations have been sent,
in the morning.

Maj. Aygar 22:19
Commander is calling me.
(Muammar) Not answering.

Col. Gürler 22:19
Kemal Başak is calling non-stop.
I'm not answering.

Maj. Çelebioğlu 22:19
[XXXX]
35 TPF 84098
32413
[XXXXXX]
N 40° 55' 19.[XX]"
E 29° 11' 10.[XX]"

[phone number] 22:20
66? Location?

Brig. Yiğit 22:21
66 is on its way.

Col. Kaya 22:23
Mr. Mehmet Tunç, high ranking
official from the municipality is
complying. He says he'll sort out
the İBB. Don't hurt/harm me, he
says. [Mehmet Tunç's phone number]

Col. Gürler 22:23
Within 10 minutes a unit will
go to the governorship.

Lt. Özgenc 22:23
Nothing is being reported on
Habertürk beyond the bridge
being closed.

Col. Korkut 22:24
212 has been passed.

Maj. Çelebioğlu added phone number.

Col. Cebeci 22:26
I sent 4 academy students to
Ümit Pasha but they need help
to intern him.

Capt. Yıldız 22:26
Main entrance of Bayrampaşa.
Conversations are continuing,
no problems.

Maj. Çelebioğlu 22:26
Capt. Kadir, when Bayrampaşa
is sorted let me know. Ankara
is waiting for information.

Maj. Çelebioğlu added phone number.

Capt. Yıldız 22:29
Bayrampaşa is pretty much ok.
They cannot exit.

Col. Kaya 22:29
Broadcasting has been totally cut off
at AKOM. It is under control.

Maj. Çelebioğlu 22:32
Istanbul police chief is coming to
the Bosporus Bridge. He must be
arrested urgently.

Col. Aygar 22:32
The order has been issued.
They are waiting.

Col. Kaya 22:36
The Logistic Support Base (LDÜ)
is under control. Planning is
underway for meals to all our troops
on the European and Asian sides
for tomorrow morning onwards.
As I do not know the overall picture,
someone who does know needs to go
to LDÜ. The LDÜ says it can provide
3 meals per day to our soldiers.

Maj. Çelebioğlu 22:39
Let's open the bridges both ways,
and tell everyone to go home.

Col. Gürler 22:39
A unit to the governorship in on
the way.

Col. Gürler 22:40
Istanbul Greater City Municipality
on the way.

Maj. Çelebioğlu 22:41
Can we get information on 66?
There are precautions placed at
TEM and the E5i exit from Istanbul,
but are there measures in place
at the entrance.

Maj. Akkaya 22:41
Provincial police HQ is on the way

Col. Kaya 22:41
AFAD provincial directorate said
that there won't be a problem at
the Governorship. He wants to
return from Edremit to Istanbul.
He supports the action. He is asking
if permission can be granted.

Col. Aygar 22:42
1st Army Command has arrived
at the bridge and ran away to
the Asian side after having come
600-700m to the bridge.

Brig. Yiğit 22:42
NTV is reporting that the bridges have
been closed by the Gendarmerie...

Lt.-Col. Düzenli 22:44
The bridges should be re-opened.
Police should be barred from crossing.

Col. Korkut 22:44
Airport main entrance and B entrance
are ok. They have complied.

Lt.-Col. Düzenli 22:44
Take the 1st Army Commander

Col. Kol 22:44
We are at the entrance Atatürk
Airport.

Lt.-Col. Düzenli 22:44
There is a guest going to Maltepe
prison, someone should greet him.

Maj. Çelebioğlu 22:44
The bridges will be opened but police
will not be allowed to cross.

Col. Kaya 22:44
TRT Radio is under control.

Col. Kol 22:44
The police here are cooperating.

Col. Şahin 22:44
Mürsel, open the bridge and put
a couple of armoured vehicles
in the middle of the bridge to
prevent police from crossing.

Col. Aygar 22:45
Received.

Col. Kol 22:45
Their superiors are coming too,
we are waiting.

No further timestamp available.

Lt.-Col. Düzenli
Are there armoured vehicles at
Atatürk airport? If not, urgently
send some.

Maj. Yanık
Hadımköy should hurry up. HAK K
[Harp Akademisi Komutanlığı] has
been reached. They have complied,
they are sitting inside.

Maj. Çelebioğlu
1st Army Commander will be taken
from Kuleli [Kuleli Askerî Lisesi].

Col. Gürler
Has Army Commander been taken?

Col. Kaya
There is an intervention going on
at TRT TV.

Capt. Yıldız
Tanks are at Bayrampaşa.

Maj. Aygar
Is the Commander of the 1st Army
coming to Kuleli himself? Has anyone
interned him?

Col. Gürler
He's still free.

Maj. Aygar
Ok.

Col. Kaya
Logistic Support Base is asking for
the settings. It would be good if the
1st Army prepared a report.

Maj. Kol
Atatürk Airport is done.
Entrances have been halted.
Exits are being allowed.

Col. Şahin
Our numbers are 20,000, including
units from Trakya.

Col. Korkut
Have 3 tanks and 4 ZMAs
[Zırhlı Muharebe Aracı].

Col. Cebeci
AKP provincial office is on its way.

Maj. Akkaya
They want to send police from
Bayrampaşa, prevent it.

Capt. Yıldız
Done.
Maj. Çelebioğlu
Not a single police officer is to leave Bayrampaşa.
Capt. Yıldız
Ok.
Lt.-Col. Düzenli
Police are not to leave Bayrampaşa. Stop AKP offices, do whatever it takes.
Capt. Yıldız
Ok. A tank has closed. They are waiting for the orders of the Police Chief.
Lt.-Col. Düzenli
All armoured vehicles should be deployed.
Capt. Yıldız
Ok. 3 GZPTs have been sent to police HQ. Bora, first lieutenant.
Brig. Yiğit 23:01
Prime Minister is making a statement.
Capt. Yıldız
No problems at Bayrampaşa.
Maj. Akkaya
Traffic at Vatan Caddesi has grinded to a halt, we can't move forward.
Col. Kaya
Taksim Square is on its way.
Col. Gürler
Has the Army Commander been taken?
Maj. Aygar
He's not arrived yet at Kuleli. I've invited him by saying that I could not control Mürsel.
Col. Gürler
Is it possible for [someone to] come to military HQ? Make sure he doesn't come.
Col. Cebeci
İBB [Istanbul Greater City Municipality] is under control, there are no problems.
Col. Gürler
Message has been sent to Trakya units.
Col. Özköse
The directive for martial law has arrived.
Col. Cebeci
Istanbul Governorship is about to be taken under control. Police at the governorship has given up resisting.
Lt.-Col. Düzenli
On the roads only stop opposition elements. And the police.
Lt. Özgenç
Commander, if we do not enable exits from the bridge, reinforcements will not be able to arrive. Need controlled exits.
Maj. Aygar
Taken.

Lt. Özgenç
Otherwise the traffic will not ease. E5 Ankara-Istanbul needs to be open, police have created gridlock.
Lt.-Col. Düzenli
Need to intervene at the Istanbul Moda Sea Club. There are many Generals there that need to be brought in.
Col. Kol
Landings are permitted at Atatürk, military aircraft is taking off.
Maj. Çelebioğlu
Ozkan [Özgenc], where is the gridlock? We're about to reach Sabiha Gökçen.
Col. Gerehan
5th Corps and 2nd Corps have been assigned with providing reinforcements to Istanbul.
Col. Cebeci
Muzaffer [Düzenli], we're about to take the Istanbul Provincial Party Chair from AKP office. I'm postponing. It's crowded outside. What can we do after [we have taken him]?
Lt. Özgenç
From Yenibosna in the direction of Ankara.
Col. Şahin
The military aircraft should take off.
Lt.-Col. Düzenli
Guys, Air Force Commander Abidin Ünal is at the Moda Deniz Club. Intervention need to be done there.
Lt. Özgenç
Edirne-Istanbul is clear.
Capt. Türk
Reinforcements for Vatan [Caddesi] comprising of 7 Military Academy cadets and 15 Petty Officers are in the helicopter. The engine has started, we're about to take off.
Maj. Çelebioğlu
Osman [Akkaya], what is the situation at Vatan [Caddesi]? Mehmet Türk, can you take Air Force Commander is there space nearby?
Capt. Türk
If we hurry we can make it to the empty space in the middle of the crowd. If need be the helicopter will open fire.
Nebi Gazneli
We want reinforcements to Taksim, crowd is gathering.
Capt. Türk
Taksim, we're in the air.
Col. Cebeci
Need urgent reinforcements to AKP provincial offices. Helicopters would work. Crowds keep gathering.
Capt. Türk
Vatan için.
For Vatan [Caddesi].

Col. Kaya
Under martial law, what will be done to the ones said to be from the Turkish Land Forces?
Col. Korkut
Shooting into the sky above the crowd at Gate B of the [Atatürk] airport.
Maj. Çelebioğlu
There are reports that they have armed the public, commander. If the crowds move towards you, we will first shoot warning shots into the air and ground and then on to them.
Celik
IMKB [Istanbul Stock Exchange] ok, interned ok, full control.
Lt.-Col. Çoşkun
We have entered governorship. It's under control, we're talking to the police to get them to agree.
Col. Şahin
In the area of the AKP provincial offices, shoot the ones that are leading [the crowds].
Lt.-Col. Çoşkun
Could have possibly gone to the governor's home. I'm waiting for the tanks, when they come we will try to take precautions. The Gendarmerie is dragging its feet and claiming they have no personnel. We may need a warning from centre. 4 tanks and 1 GZPT [Geliştirilmiş Zırhlı Personel Taşıyıcı] have arrived. They've been sent towards governorship now.
Col. Korkut
There is resistance at Atatürk, reinforcements needed.

Maj. Karabekır shared two photos.

Maj. Karabekır
Acibadem is done, about to hit the road.
Maj. Çelebioğlu
Mehmet, let's not share nonessential photos.
Col. Kaya
Haber7 is unnecessarily broadcasting.
Maj. Karabekır
Ok [emoji].
Lt.-Col. Düzenli
Civil disobedience to military forces will be harshly dealt with. Media organs not on side will be silenced.
Col. Şahin
Such broadcasting organs should be attacked by air force, give the order.
Maj. Aygar
Our guys at 1. Bridge have a police radio, and are saying that the police have made an announcement for buses and trucks to create gridlock. Unit of reinforcements will be blocked.

Col. Gerehan
Info: 20 police vehicles are headed towards Kozyatağı.

Col. Şahin
Air Force must immediately step in.

Col. Korkut
Need reinforcements of foot soldiers at Atatürk Airport.

Maj. Çelebioğlu
Col. Uğur [Çoşkun], did you get the traffic under control?

Lt.-Col. Çoşkun
Sakarya Provincial Police Chief has been informed but he said refused to acknowledge and said that he was going to inform the governor. I will confirm that orders have been issued to the Gendarmerie.

Maj. Çelebioğlu
Commander, the Gendarmerie should take him. Stop traffic from coming to Istanbul.

Lt.-Col. Çoşkun
The governor is attending a wedding at Hendek and could not be interned. Ok.

Maj. Akkaya
We cannot access Vatan [Caddesi] and need air support.

Col. Cebeci
The governorship is trying to resist. The meeting is continuing.

Lt.-Col. Çoşkun
It has been requested that we show resistance to Police Chief. This could turn ugly.

Maj. Aygar
We've stopped one bus full of riot police. They submit. We took their TFs, we're doing road checks together.

Col. Korkut
We're about to reach the control towers of Atatürk Airport. Aircraft will only be permitted to land.

Col. Atmaca
Is there anything to be done on the Küçükçekmece side? 1 motorised team is ready.

Maj. Aygar
Is there any news on the Commander of the 1st Army? He hasn't arrived at Kuleli. The helicopter has arrived, they are ready and waiting.

Lt.-Col. Çoşkun
The governor and police chief are probably together. The order has been given for the necessary measures to be taken when they are seen.

Col. Şahin
We can't get news from the Commander of the 1st Army.

Maj. Çelebioğlu
Col. Zeki [Atmaca], don't bring vehicles into Istanbul. Col. Uğur [Çoşkun], has the traffic been halted where you are?

Col. Cebeci
AKP Istanbul provincial office is under control. People are being interned.

Maj. Akkaya
I'm planning to open fire on provincial police HQ. There's no other choice.

Maj. Aygar
The police are preparing to intervene on the 1st Bridge. Armoured police vehicle is drawing close. Need armoured vehicle support. Or helicopter.

Col. Gerehan
Calling Army Commander, he's not picking up. Can his location not be found out?

Lt.-Col. Özgenç
We've opened up the F5 now, it's going to clear up.

Col. Cebeci
There are around 3,000-4,000 people at the AKP Provincial Office. Need back up.

Maj. Aygar
2 tanks and 2 armoured personnel carriers (APC) have reached the 2nd bridge. No problems reported.

Maj. Yanik
Colonel [Ahmet] Gümüş from the Air Force said that the unit for media is on its way.

Lt.-Col. Düzenli
Response to crowds and any police who resist will be harsh, and dealt with by use of firepower and tanks. Colonel Sadık [Cebeci], what is your location?

Col. Cebeci
The AKP provincial office.

Lt.-Col. Düzenli
I'm asking about the AKP provincial office, where is it?

Maj. Yanik
4 armoured personnel carriers [APCs] have entered Selimiye.

Lt.-Col. Düzenli
Let's use the troops actively. Locations that are awaiting reinforcements must be bolstered.

Col. Cebeci
[Gives directions to the AKP provincial office].

Col. Gerehan
66th Mechanised Infantry Brigade is withdrawing from Istanbul Police HQ??? Orders were given to the battalion commander and he stopped. Selim's [Cebeci] informed me.

Lt.-Col. Düzenli
Apparently the governor, Army Commander and 23rd Motorized Infantry Tactical Division are at AKOM.

Capt. Türk
We've arrived at Vatan, we're trying to find the group.

Lt.-Col. Çoşkun
News is circulating on the internet that the Chief of the General Staff has been arrested. Trying to affect our troops morale. Can precautions be taken?

Capt. Çınar
It's not possible to reach the entrance of Sabiha Gökçen Airport because of civilian traffic. Also PÖH [Police Special Operations Department] have informed the Gendarmerie that they will fight. As soon as we get through this civilian traffic, we'll fight.

Lt.-Col. Çoşkun
The police are using the civilian crowds against us, there is resistance. Is air support possible?

Col. Şahin
Guys, everything is progressing as planned. These TV channels need to be silenced.

Lt.-Col. Çoşkun
In Sakarya they're using the mosques to call people out on to the streets. They are also making the same call in districts. Support is needed. The Chief of Staff of the Sakarya Gendarmerie has instructed the Gendarmerie to ignore our orders. The crowds are marching on the units. Urgent support is needed.

Col. Kaya
The crowd at Taksim is cheering, chanting "the greatest soldiers are our soldiers".

Col. Gerehan
Commander of 66th has apparently told his units to withdraw. Precautionary measures??

Maj. Aygar
They are whipping up fury among the public. Is there no way to stop it?

Lt.-Col. Düzenli
UNITS WILL CONTINUE AND RESPOND IN THE HARSHEST MANNER.

Col. Gerehan
A team has been sent to NTV. Is an airborne vehicle is available.

Lt.-Col. Düzenli
IT IS GOING WELL.
MAY GOD HELP YOU.

Col. Kaya
They've turned Taksim. Our guys are shooting.

Col. Baykal
We're in a bad way at the Istanbul Stock Exchange.

Maj. Çelebioğlu
The messages written in capslock above are from Lt.-Col. Muzaffer Düzenli in Ankara .

Col. Gerehan
The blockade on the bridges is creating traffic problems. Reinforcements cannot get through?

Lt.-Col. Çoşkun
Aegean Army Commander has called by phone. Is there any need to answer the call?

Capt. Yanık
No there is not, Commander.

Maj. Ozleblebici
From 65th, 2 mechanised and 1 motorized infantry brigade is about to hit the road.

Lt.-Col. Çoşkun
Ok.

Maj. Çelebioğlu
Col. Mustafa Kol has lost his mobile.

Col. Kaya
Crowd has come to the Logistic Support Base. We're going to shoot.

Col. Şahin
Reinforcements on the way.

Col. Kaya
Crowds are growing at the LDU. Our guys have temporarily emptied it. The other side is spreading false news.

Maj. Aygar
The situation at the 2. Bridge is bad. Urgent helicopter support needed.

Col. Şahin
Request sent.

Maj. Aygar
The broadcasting from the mosques must be stopped.

Col. Gürler
Army Commander is near the bridge.

Maj. Karabekır
They stopped me on the way, I opened fire. There are injuries. It's opened, I'm continuing. I'm by Optimum.

Maj. Çelebioğlu
Continue Mehmet [Karabekır].

Maj. Karabekır
No compromise, no hesitation.

Col. Cebeci
Crowd is growing in front of the the AKP provincial offices. We're firing. Need ZPT or a tank.

Maj. Çelebioğlu
What is needed will be done Osman [Akkaya].

Col. Kol
We're at the control tower at Atatürk Airport. We are giving permission for landings, take offs are cancelled.

Maj. Çelebioğlu
Are there any armoured units close to Maj. Muammer [Aygar]?

Lt.-Col. Çoşkun
Go to Istanbul, under control.

Maj. Aygar
Need armoured vehicles for First Bridge.

Maj. Çelebioğlu
Col. Sadık [Cebeci], let's shoot into the air first.

Maj. Aygar
Same for Second Bridge.

Maj. Karabekır
Don't dare hesitate, hit them.

Col. Cebeci
Ok.

Col. Kol
I'm allowing for flights to land. Can you confirm?

Lt.-Col. Çoşkun
Except, there are families with children trying to get to Sakarya and are stuck in traffic. Trying to help.

Maj. Aygar
I need [Tuğgeneral Mehmet] Partigöç Pasha's mobile number.

Col. Kol
Doğan, 4.4 military aircraft is ready for take off at Atatürk. Shall I give the go ahead?

Maj. Çelebioğlu
Commander, keep the military plane where it is. Permit landings.

Maj. Yanık
[phone number provided for Partigöç Paşa].

Maj. Çelebioğlu
Announcements should be made to tell people to go home.

Col. Şahin
Don't lose your cool and put down your weapons.

Col. Cebeci
Privately owned TV stations must be silenced.

Lt.-Col. Düzenli
Friends, thankfully we have captured several targets in Ankara and in Istanbul. The statement has been read on TRT. We continue as is. Anyone who opposes our act will be dealt with harshly. This is the order.

Capt. Türk
We can't unite, where is the Vatan [Caddesi] group? We are in front of the Bezmialem University.

Col. Şahin
Irfan, if you are able to go to Taksim, then go.

Maj. Çelebioğlu
Osman Akkaya 0(506) 501 50 96.

Capt. Türk
A really large crowd is drawing near.

Lt.-Col. Coşkun
At the governor's office the police and the crowd have joined forces. They are telling our troops to surrender. Reinforcements are needed. We are out numbered.

Maj. Çelebioğlu
Mehmet Türk call Osman Akkaya.

Col. Kaya
Reinforcements are needed at Taksim. Can armoured vehicles be sent?

Lt.-Col. Düzenli
Units must maintain control at airports and public squares. These locations must be kept under control. Units will not withdraw.

Col. Kaya
We are sending one column to Taksim.

Col. Şahin
Public squares will, under no condition, be emptied.

Lt.-Col. Çoşkun
Urgent support needed at Sakarya. Crowds are trying to stop the tanks.

Maj. Karabekır
Sabiha Gökçen shoot straight, right, left. There are problems there.

Maj. Aygar
We have shot 4 people who were resisting at Çengelköy. Everything's fine.

Lt.-Col. Çoşkun
Need urgent air support for Sakarya.

Col. Şahin
Irfan, send troops to Taksim in a secure manner. Correction: to Üsküdar.

Col. Yusuf [?]
I've taken over command of 66th Mechanised Infantry Brigade, we are not withdrawing. May God help us.

Col. Şahin
May God help us.

Col. Kaya
Commander, pro-government media is continuing.

Col. Gürler
2nd Corps Commander says he will not deploy his units. We said it was an order issued by General Staff. He says he won't give green light.

Col. Kaya
We're sending reinforcements from TRT TV to Taksim Square.

Capt. Türk
Phone number for Osman Akkaya?

Maj. Çelebioğlu
Osman Akkaya mobile (number provided).

Lt.-Col. Çoşkun
HQ of the Aegean Army [Fourth Army] has been communicating that no actions are to be taken without orders issued from them.

Maj. Çelebioğlu
Fatih Sönmez is there (number provided).

Col. Atmaca
The satellites at Çamlıca immediately need to be taken under control.

Lt.-Col. Çoşkun
We're not listening [to the directive issued by the Fourth Army]. However units are in a precarious situation. Citizens have entered the governorship.

Col. Şahin
Units should stay where they are.

Col. Kaya
Yeni Şafak has published the Commander of the 1st Army's statement.

Capt. Turk
We are not able to contact the unit at Vatan [Caddesi]. We communicated when we initially arrived. They had said it was impossible for us to meet.

Col. Kaya
Osman [Akkaya] we need armoured vehicles at Taksim.

Lt.-Col. Çoşkun
Urgent support needed for Sakarya.

Lt.-Col. Düzenli
Uğur [Çoşkun] if you are not able to exert control, then fall back.

Col. Kaya
Fighting at TRT Radio. They are returning fire. Need armoured unit reinforcements.

Lt.-Col. Çoşkun
Roads are blocked, withdrawing is also hard, but we will try.

Col. Şahin
If needed shoot into the crowd gathered at Vatan Caddesi.

Lt.-Col. Düzenli
Withdrawal is only for units in Sakarya. Other units are continuing as planned.

Maj. Aygar
There's a problem at 2. Bridge. Need urgent helicopter support.

Col. Kaya
Need armoured vehicle support at [TRT] Radio. Osman [Akkaya] can you send any? Armoured vehicles to Taksim.

Lt.-Col. Düzenli
There must be a response from the airport.

Col. Kaya
Media is continuing.

Maj. Çelebioğlu
Need to get armoured vehicles shooting at Police HQ on Vatan immediately. I can't reach Osman Akkaya and Fatih Sönmez. Mehmet Türk, where are you?

Col. Şahin
The tanks that have Çamlıca hill in range should attacks the antennas. Irfan can you go to Çamlıca and carry out attack?

Col. Kaya
There's a protest at TRT TV. Situation is normal.

Col. Atmaca
We should go to the centre that controls the lines to the antennas and cut the lines.

Col. Kaya
At TRT TV, our guys are firing. Situation is normal.

Col. Şahin
Friends, we are steadfast and waiting for reinforcement patiently.

Col. Kaya
The crowd at Taksim is large.

Col. Cebeci
The reinforcements from Trakya must come.

Col. Gerehan
If we are able to send aircraft to First Army base, we can get troops to CNN and places.

Maj. Aygar
Need a helicopter for 1st and 2nd Bridge. We have shot 20-30 people. But our guys at the 2nd bridge are struggling. Need helicopter.

Lt.-Gen. Düzenli
Passing on an order: CROWDS THAT HAVE GATHERED WILL BE FIRED ON. CROWDS THAT ARE COMING UNDER FIRE ARE DISPERSING.

Maj. Aygar
They are broadcasting using the central system of the mosques.

Maj. Aygar
Could an air assault on the 2. Bridge be considered?

Col. Kaya
Taksim are saying they cannot take anymore.

Col. Şahin
For as long as our strength holds out, friends

Maj. Aygar
Plane for 2. Bridge?

Col. Kaya
Muzaffer [Düzenli]?

Col. Kaya
Soldier has been wounded in front of TRT Radio. We're calling for an ambulance but 112 is not responding. He's been shot in his leg. Apparently it's bad.

Lt.-Col. Çoşkun
They are trying to enter the main garrison with bulldozers in Sakarya, the situation is critical.

Col. Kaya
There is a battery problem with communication to Taksim. The planes shot three times just now. To where, we don't know.

Col. Gerehan
Like the Asian side.

Col. Kaya
The planes worked for Taksim. It's calm now.

Maj. Aygar
Can we do the same for the 2. Bridge?

Col. Kaya
The planes are important for morale. When it gets light can we increase air support?

Maj. Karabekır
A Kobra has arrived to where I am. Help.

Col. Kaya
The Taksim team has been caught? So it is being said. We are trying to confirm. Taksim team has been caught. The remainder are falling back to the radio building.

Col. Şahin
Reinforcements are on their way.

Lt.-Col. Çoşkun
The crowd are asking the police to hand me over. Shall we open fire? The crowd is large.

Capt. Turk
We're 17 person reinforcements about to lift off in the helicopter headed to CNN.

Lt.-Col. Çoşkun 01.26
Our men at the governorship have been overrun by the crowd, they are handing them over to the police. The police are trying to prevent the crowd, but it is hard.

Maj. Karabekır
Crush them, burn them, no compromise.

Col. Gerehan
C'mon Mehmet.

Lt.-Col. Çoşkun
If we open fire we'll hit 3 or 5 but we won't be able to stop them from entering.

Col. Baykal
IMKB [Istanbul Stock Exchange] is about to fall. They've broken the doors.

Col. Kaya
We must stop the broadcasting.

Col. Baykal
Need help.

Lt.-Col. Düzenli
FRIENDS, RESPOND WITHOUT HESITATION.

Col. Şahin
Units from Trakya are on their way.

Col. Kaya
Send support to Taksim. Can the broadcasting not be cut?

Col. Şahin
We're trying to cut it off.
Col. Kaya
The threat at AKOM has been squashed.
Col. Doğan
What is Erdal Pasha saying?
Col. Kaya
We are silencing the Arıcılar Mosque.
Lt.-Col. Çoşkun
The police have taken 15 of our personnel to the police station at the governorship and called in a prosecutor. They are trying to take their guns. Communication has been cut off from other personnel at the governorship. The situation is critical here.
Col. Şahin
Col. Yusuf what was the situation?
Col. Kaya
Arıcılar mosque has been silenced.
Maj. Aygar
We're about to lose the Second Bridge.
Col. Kaya
They are continuing with fake news.
Col. Gerehan
But there are 2 tanks and 2 APCs waiting at Selimiye?
Maj. Yanik
The order from Ankara: OPEN FIRE.
Col. Doğan
Just as the Fifth Army Corps did not allow for reinforcements, its given orders for a group of about 100 officers, sergeants, and specialists to be formed. Probably will be sent to counter our operation.
Col. Gerehan
At Selimiye, we are 2 officers and 11 soldiers ready for helicopter.
Maj. Karabekır
I don't have a Kobra where I am. I guess they are trying to surround it. Keep fighting.
Col. Şahin
Reinforcements are on their way.
Maj. Karabekır
Don't get demoralised, we continue until the very last drop of our blood.
Col. Doğan
I'm sending a battalion from Lüleburgaz. One tank battalion is also getting ready.
Col. Kaya
Needed at Taksim, Commander.
Col. Doğan
I'm holding one battalion at the garrison for security and in the event that events happen in Lüleburgaz. 47th [Motorised Infantry Regiment] asked for [reinforcements], going to send to them.
Col. Şahin
There's no need for garrison security, commander.

Col. Doğan
Ok, I send that [brigade] too.
Col. Kaya
Taksim is important, Commander.
Col. Doğan
Ok, shall I stay where I am?
Col. Şahin
All battalions should be deployed, Commander.
Maj. Karabekır
Do the artillery brigades have ammo? Or shells?
Col. Şahin
Yes.
Maj. Karabekır
It can be tried. In open spaces where there is no Kobra, can rely on machine gunfire from the helicopter.
Col. Kaya
Ok, I'm passing on the message.
Capt. Türk
We're close to CNN. We're under heavy fire. Some have been hit.
Maj. Karabekır
Airforce is not necessarily needed.
Capt. Türk
Need medical team at 66th now.
Col. Kaya
Helicopter fire power support to Taksim?
Capt. Türk
Get it prepared. 1 hit in the thigh, 1 hit in the leg.
Maj. Karabekır
Infantry with rifles inside the helicopter would also work, just as long as they don't shoot soldiers.
Col. Gürler
My official number.
Col. Şahin
May God help you.
Maj. Karabekır
[Two clapping emojis]
Col. Gerehan
Can you add Eyüp Pasha's official number?

Maj. Çelebioğlu added phone number

Col. Kaya
Situation at Taksim is really critical.
Capt. Türk
The ambulance is at the garrison. Guys, would Medipol hospital in Bağcılar be ok? The bullet hit his thigh, there's a bit of bleeding.
Maj. Çelebioğlu
Of course they should take him.
Maj. Yanik
He should be taken.
Capt. Türk
We are calling a military ambulance.

Col. Kaya
The situation at the Radio building is critical. They are entering the building from all sides. Helicopter to Taksim then to support here.

[Phone number] changed the title of the conversation to "We are Peace at Home" [Yurtta sulh B iziz"]

Col. Kaya
Where did the planes bomb?
Maj. Aygar
Kuleli shook. Is it Çamlıca?
Col. Kaya
It was heard somewhere close to Hasdal. Taksim is bad. Taksim radio is really bad. Taksim radio is really bad. They want an answer.
Col. Doğan
The police have put up a barricade at Lüleburgaz. Might lead to fighting with our troops.
Maj. Karabekır
Show no compassion. Don't falter as we are about to win. No communication with 2nd Armoured Brigade?

[phone number] left

Lt.-Col. Düzenli
I'M PRESENTING ORDERS. USE GUNFIRE TO DISPERSE CROWDS THAT HAVE GATHERED.
Col. Kaya
They are bringing heavy duty machinery close to AKOM. Our units are firing on them.
Col. Şahin
Use gunfire to respond, don't let them get close.
Maj. Karabekır
As someone who is in the field, I am firing, firing on to the crowd and waiting. Keep repeating and exercise restraint. They are dispersing. 10-15 people are done for. Don't lose momentum.
Col. Kaya
They've fired. It's not possible to see anything. They've fired into the depo of the vehicles going to Taksim. The vehicles are not moving.
Maj. Aygar
Heavy fighting at Kuleli. We are firing on a group.
Col. Kaya
The situation in Taksim is critical.
Lt.-Col. Düzenli
CROWDS THAT ARE COMING UNDER FIRE ARE DISPERSING. MAY GOD HELP YOU.

Col. Kaya
The unit at Taksim has gone to the Lojman at Beşiktaş. The planes are flying.

Maj. Aygar
Our guys are evacuating the 2. Bridge. There is intense fighting at Kuleli, toward Beykoz area.

Col. Kaya
Special Units have apparently arrived at Taksim. Air support?

Maj. Aygar
Those planes are not our planes?

Maj. Karabekır
Green, yes.

Col. Kaya
The police are about to launch an operation on AKOM. Can we get air support for Taksim and AKOM? The situation is critical.

Col. Baykal
Control has been restored at IMKB [Istanbul Stock Exchange]. Crowd has been dispersed.

Maj. Karabekır
Control of Acibadem is good.

Col. Baykal
The police have quietened now. We have ammo, morale is high.

Col. Kaya
Police have surrounded Taksim and TRT Radio with armoured vehicles. They are continuously throwing teargas. Air support, planes should fly low over Taksim. They've taken soldiers at Taksim. Taksim, TRT Radio, the teargas, and a big crowd— it's really bad.

[phone number] left

Talip Guler left

Col. Doğan
Have any generals been killed? Habertürk is reporting that a coupist general has been killed.

Maj. Aygar
There's police movements on the Asian side of the 1s t bridge. 1 TOMA has been hit.

Capt. Türk
66th is fighting police.

Maj. Aygar
They are dispersing the crowd.

Maj. Çelebioğlu
Commander, we too are trying to stay alive.

Maj. Aygar
How is Ankara?

Maj. Çelebioğlu
Do what it takes to stay alive. Mehmet Türk, take precautions. Don't lose lives.

Capt. Türk
We're fighting, there are dead police.

Maj. Çelebioğlu
I've confirmed it from Ankara.

Capt. Türk
Meaning?

Maj. Çelebioğlu
Surrender.

Maj. Aygar
Did they take the head of the snake?

Maj. Çelebioğlu
Or flee.

Maj. Aygar
Murat, Kuleli? 1. Bridge.

Turgay Odemiş
Yes.

Maj. Aygar
Muzaffer [Düzenli], succeeding or not?

Maj. Karabekır
Shall I go to the 1st Army?

Maj. Çelebioğlu
How will you stay alive Commander? Same goes for 65th.

Col. Doğan
The battalion I sent from Lüleburgaz never made it past the police barricade. The police arrested the battalion commander.

Col. Kaya
And the others?

G-4 Ozkan left

[phone number]
V F

Col. Doğan
Corps Commander stopped a battalion commander. He's saying he's not taking troops out. In this case the other commander's deputy can't get it done. Never can.

Maj. Çelebioğlu
He shouldn't leave, commander.

Maj. Aygar
Has the operation been cancelled Murat?

Maj. Çelebioğlu
Yes, commander.

Col. Doğan
Immediately something asymmetrical must be done higher up. Otherwise the problem may grow below.

Maj. Aygar
We're quitting??

Col. Doğan
Which operation, all of it?

Maj. Çelebioğlu
Yes quit, Commander.

Col. Doğan
Meaning?

Maj. Çelebioğlu
Yes, Commander, operation aborted.

Maj. Aygar
Ok.

Col. Doğan
Shall we escape?

Maj. Çelebioğlu
Stay alive, Commander. The choice is yours. We have not decided yet. But we have left our position. I'm closing the group. Delete the messages if you want.

[phone number] left

Col. Gerehan
Password 4.

Lt.-Col. Düzenli left

Col. Kaya left

[phone number] left

[phone number] left

[phone number] left

Fatih Sonmez left

[phone number] left

[phone number] left

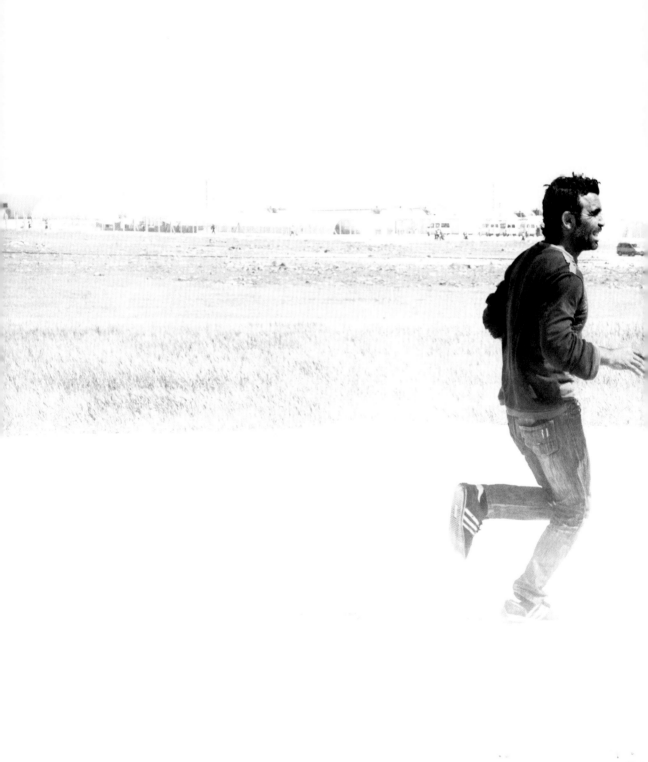

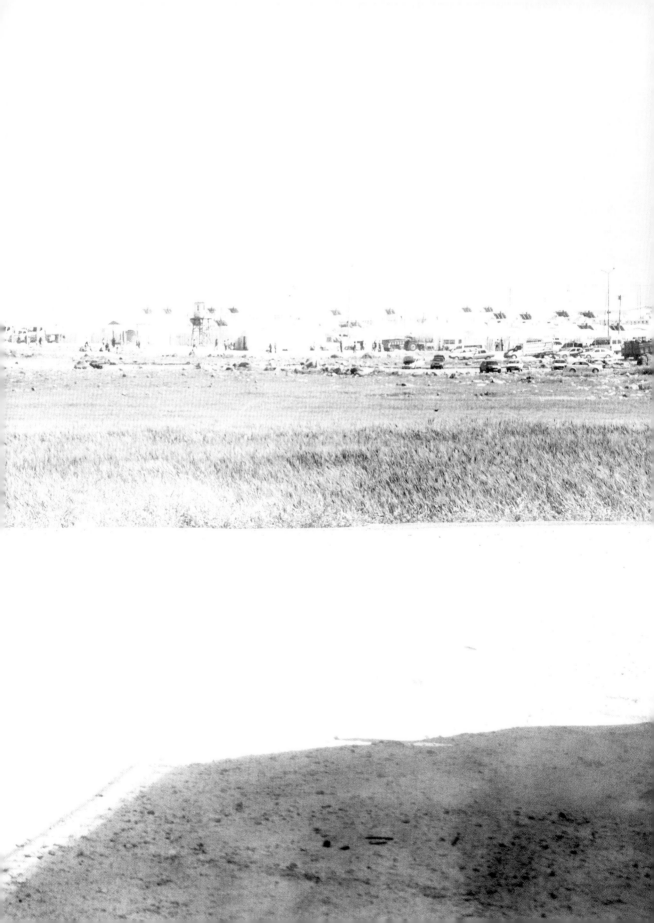

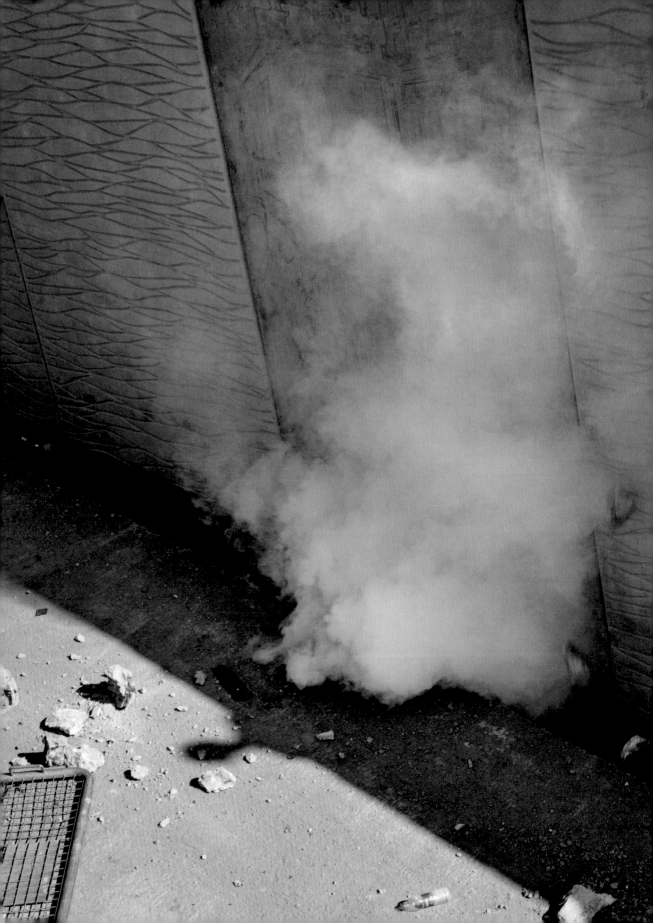

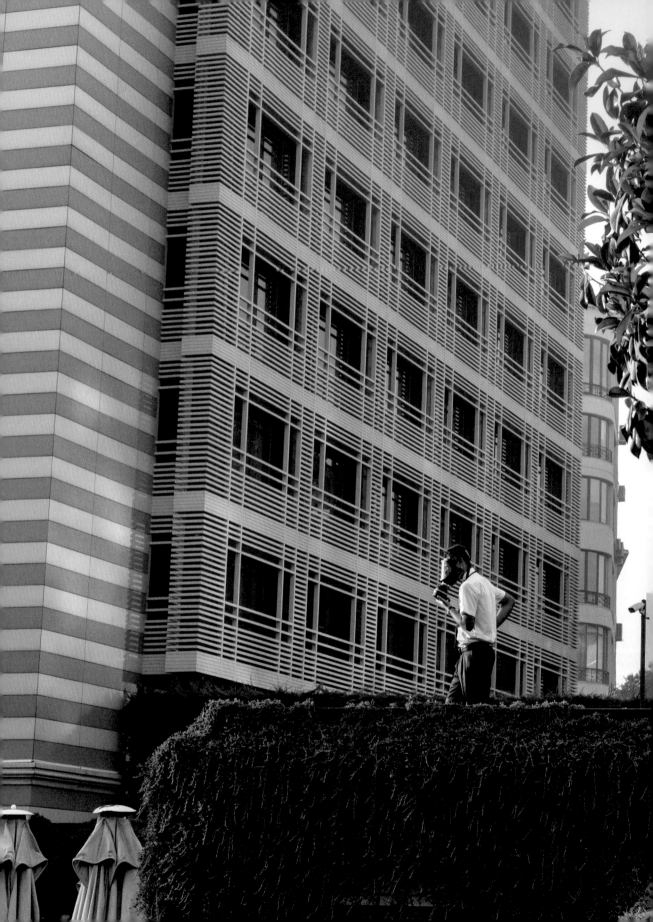

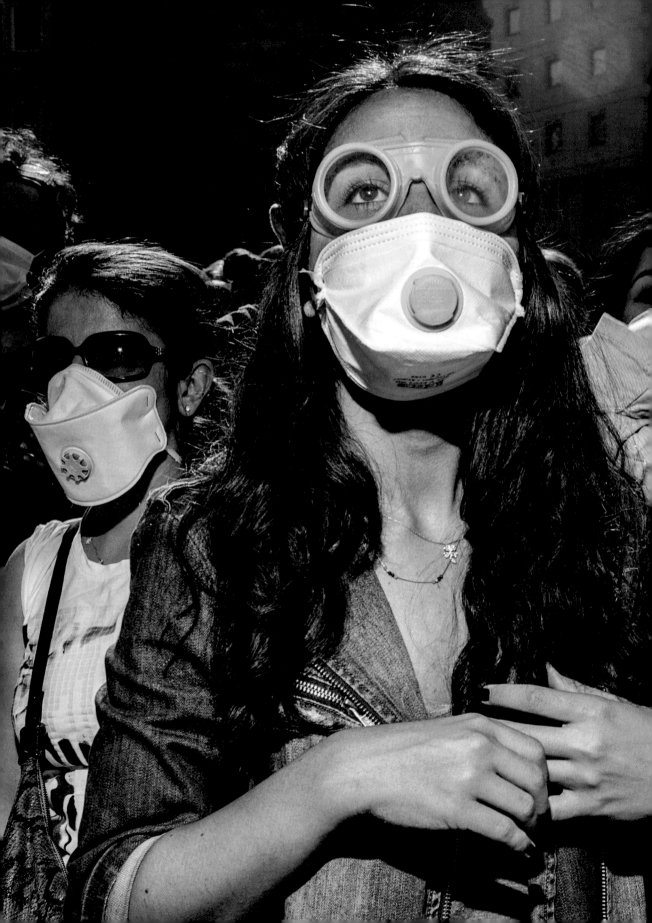

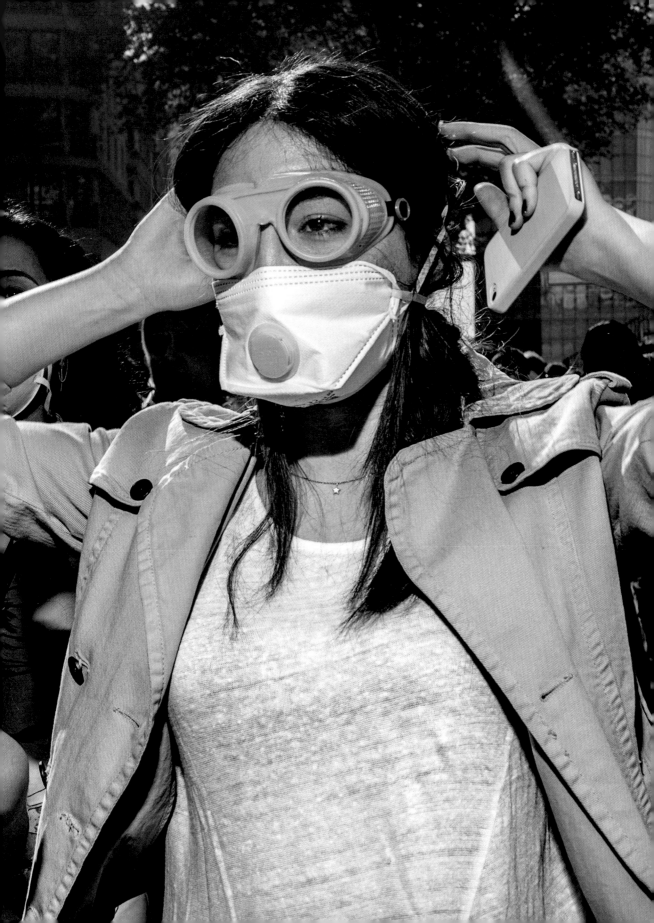

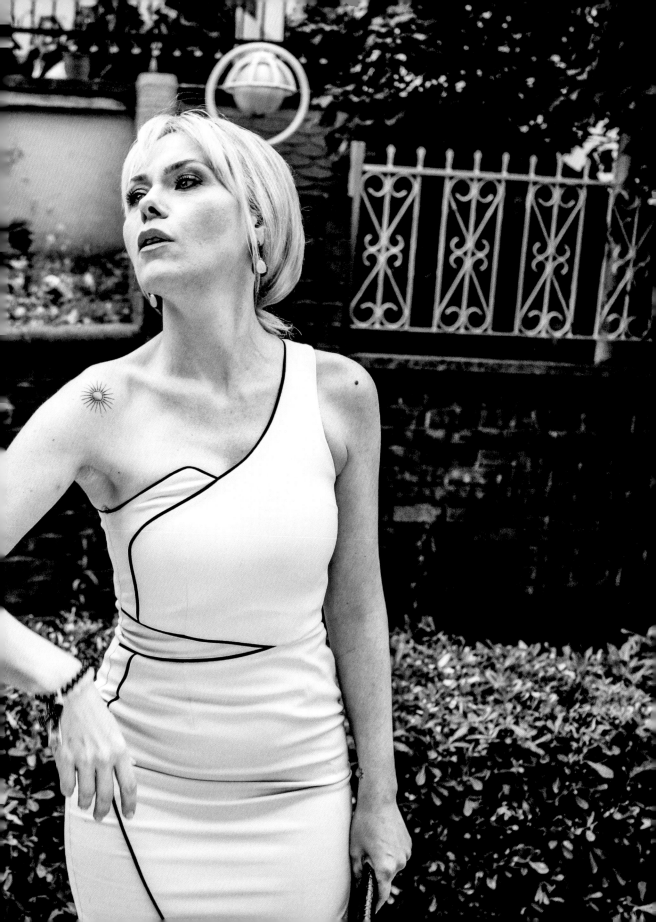

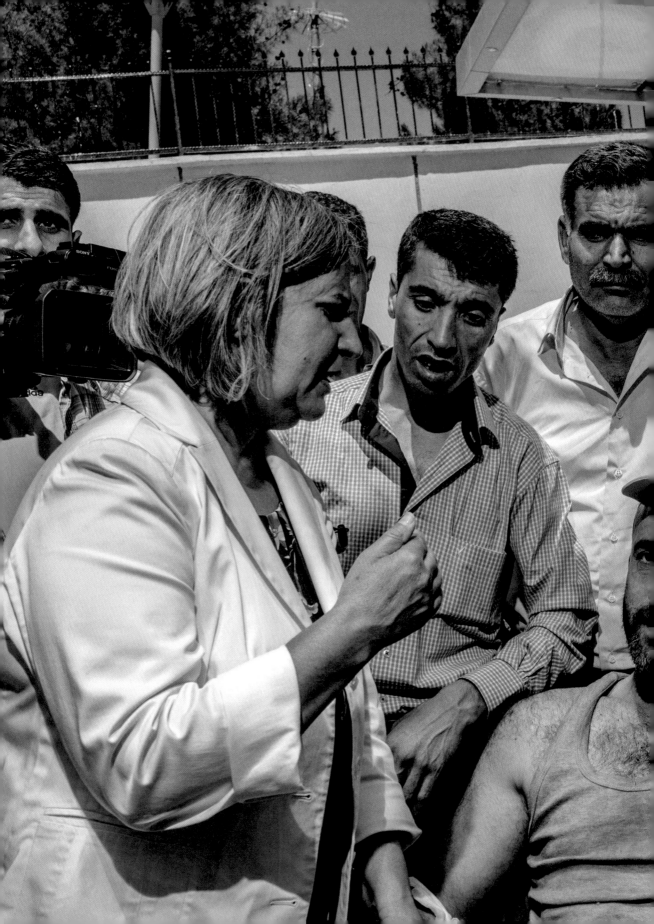

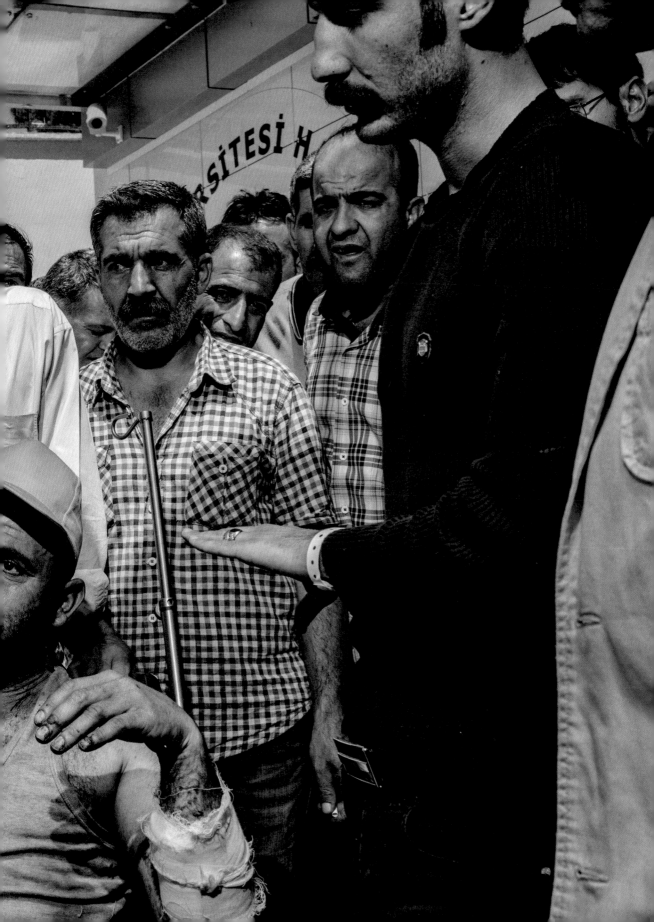

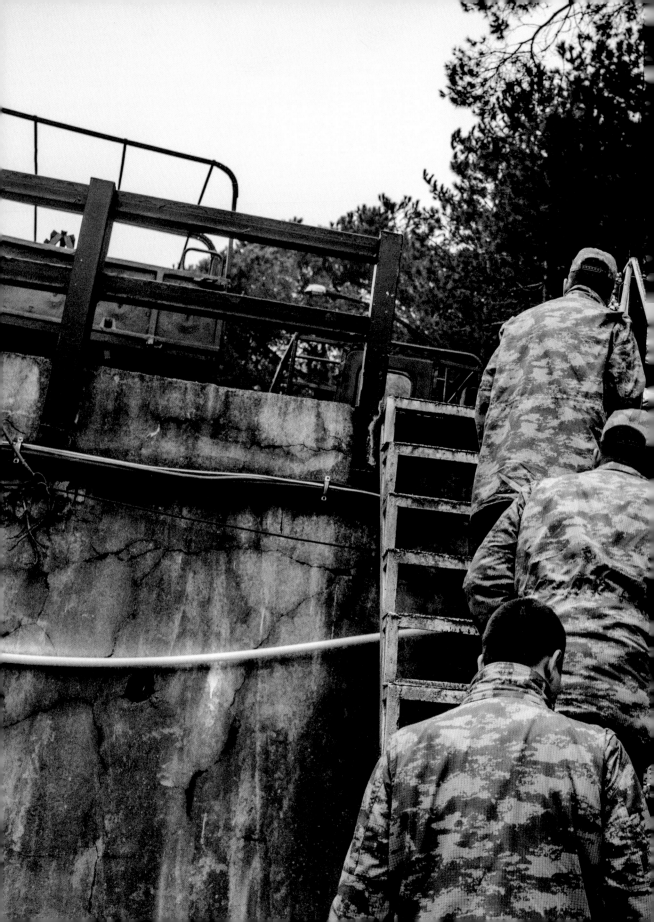

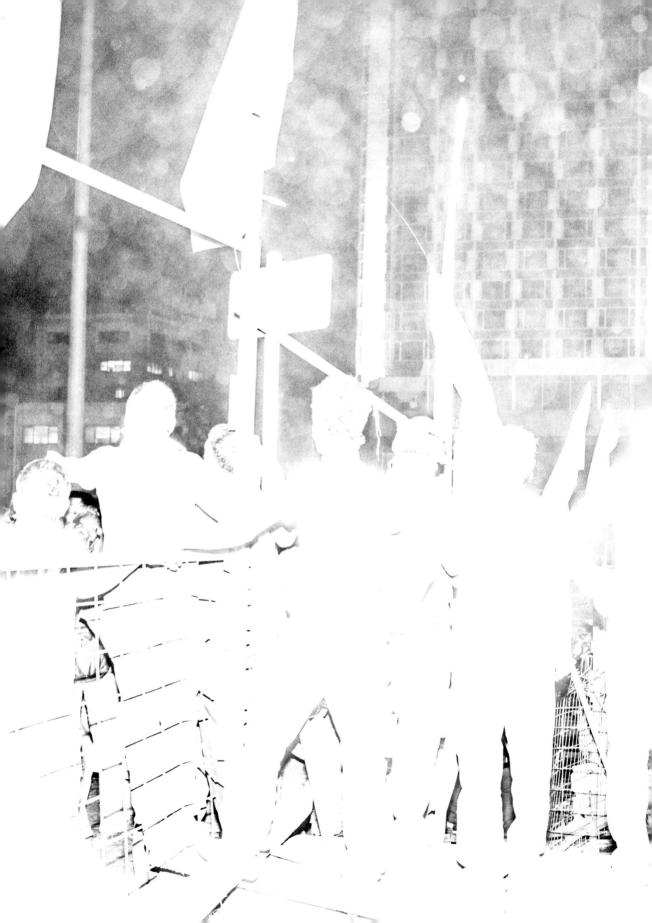

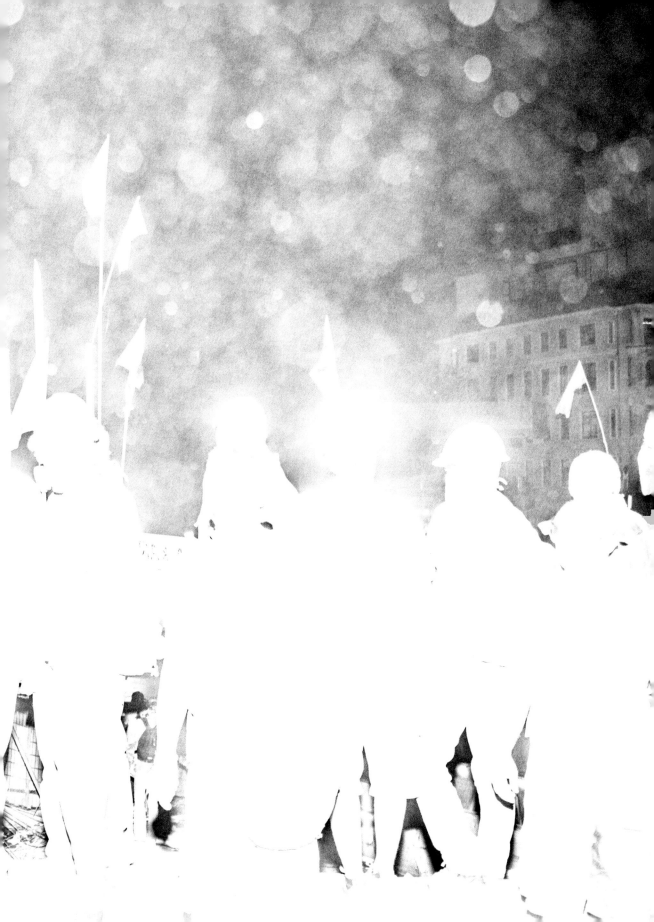

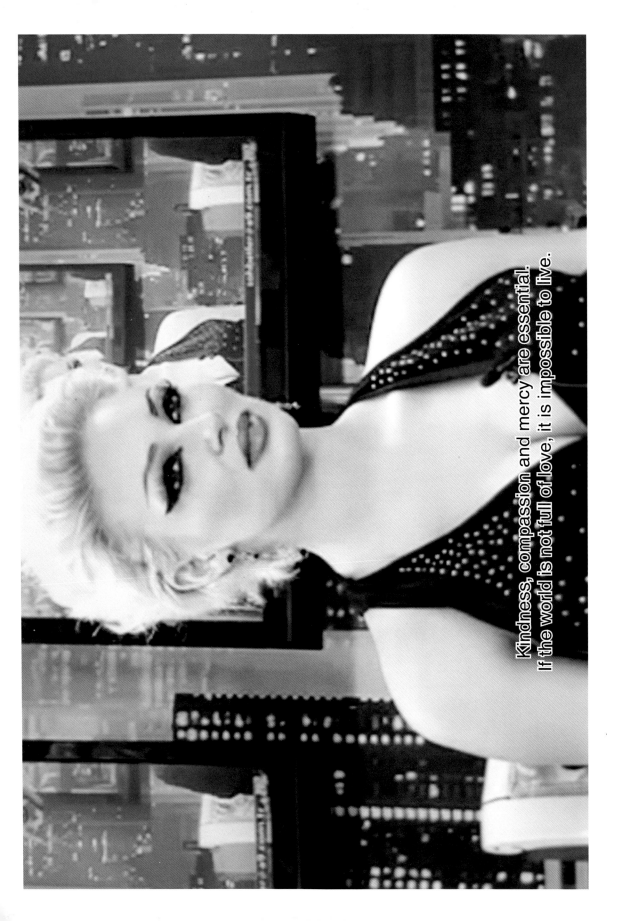

Kindness, compassion and mercy are essential. If the world is not full of love, it is impossible to live.

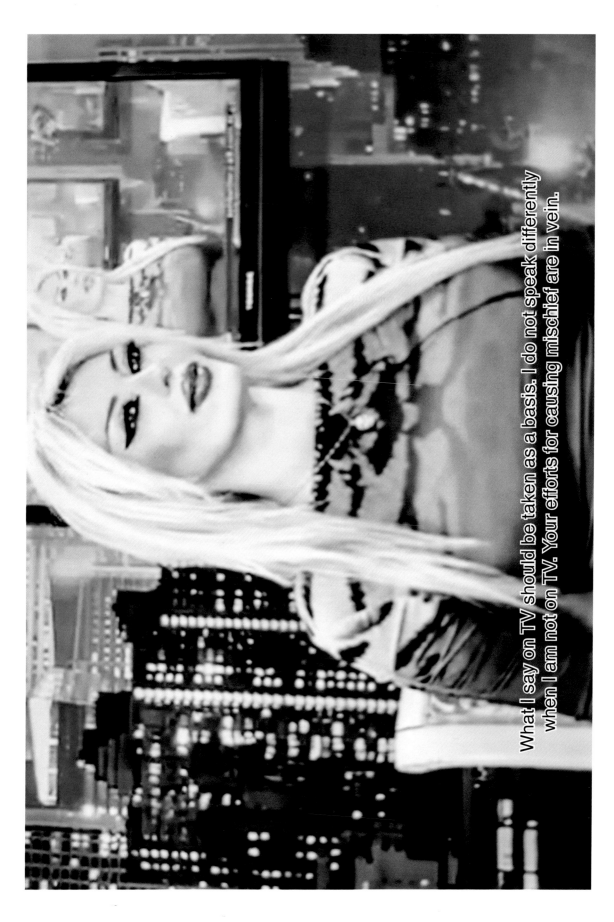

What I say on TV should be taken as a basis. I do not speak differently when I am not on TV. Your efforts for causing mischief are in vein.

Their salaries need to be good.
They need to be respected.

The more nonsense grows,
the more extreme it becomes.

Treat them with love and warmth.
They will relax if they know they are loved.

Of course that's right.
People who love will come together.

The signals reach the brain; inside the brain the soul converts it to light and colour. Inside of a brain is very dark, if you open and look.

Hypocrites employ utterly evil methods on the internet.
And they learn these methods from whom?

There are a few different forms of sleep. Death is a form of sleep where the vision is sharper and more vivid. Martyrdom is also a distinct form of sleep.

Everyone should condemn that attitude.

Then there is something wrong.
That is dyed in the wool racist and a far cry from love.

How can you divide our brothers from us?
That is out of the question.

There are many parallel universes that intersect and intertwine.
There are not one or two parallel universes.

They refrain from violence and sedition.
They never participate in such shady activities.

At the moment of death,
the person reviews this life as merely a dream.

Who knows what they did to incur the fury of the deep state?

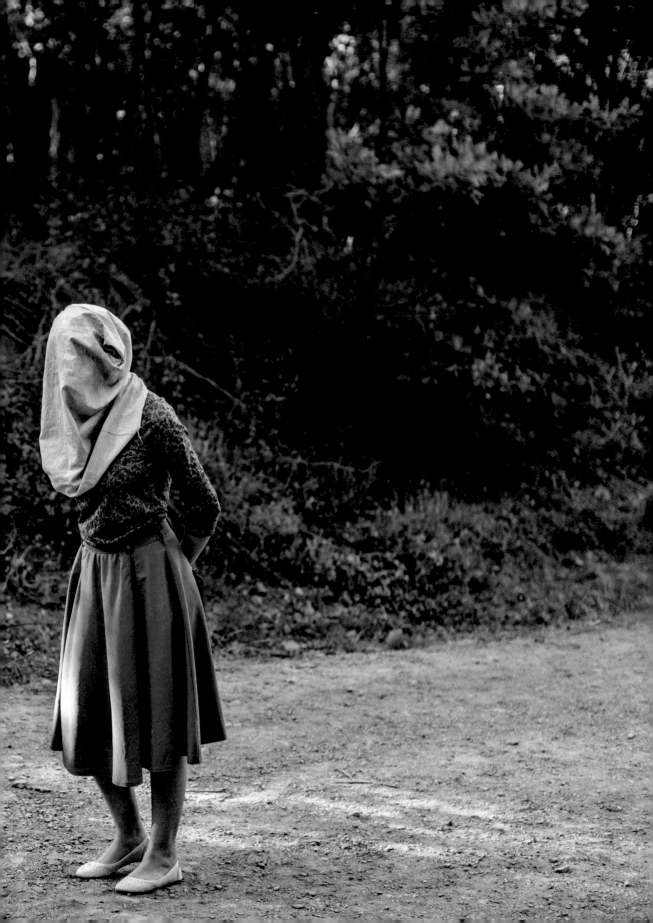

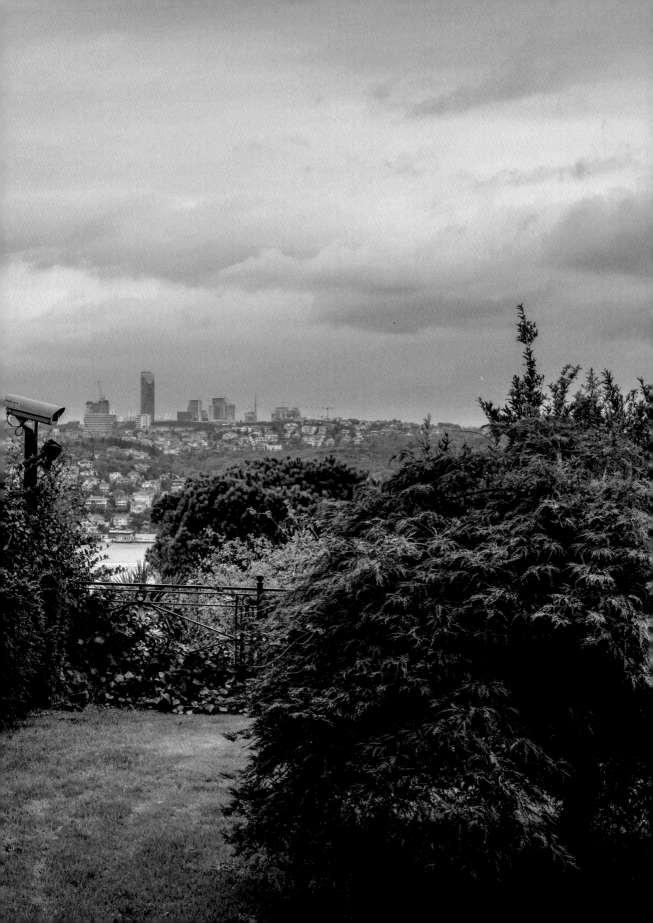

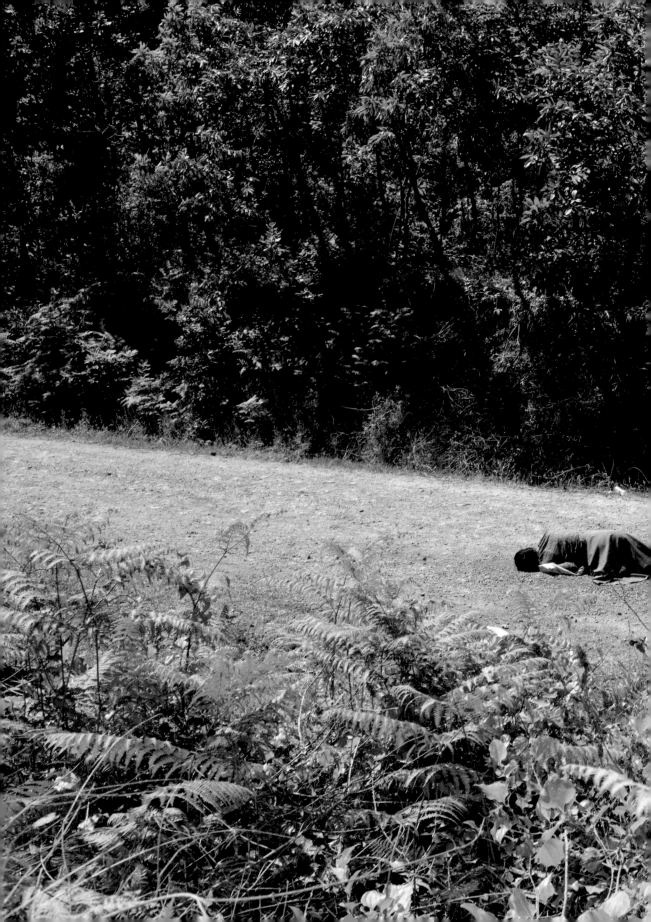

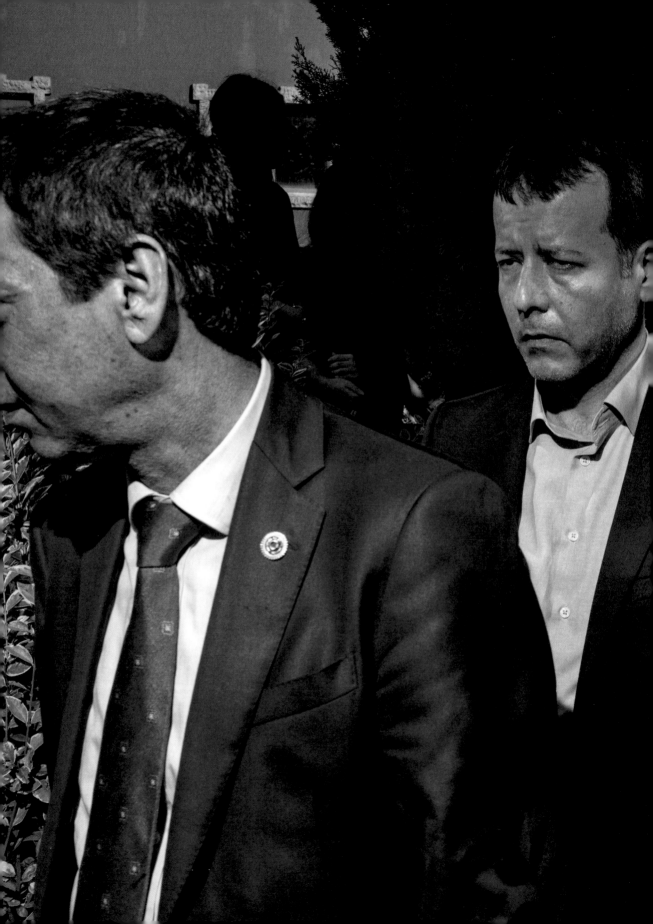

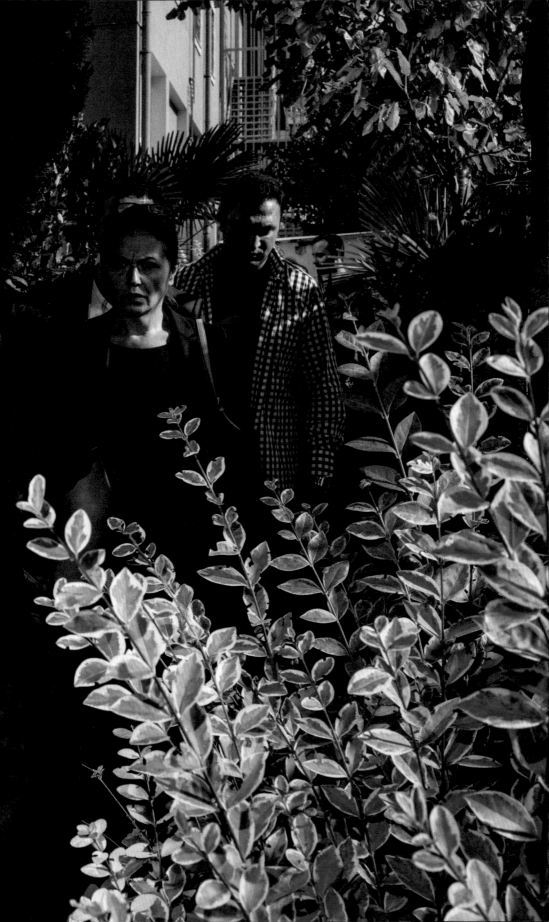

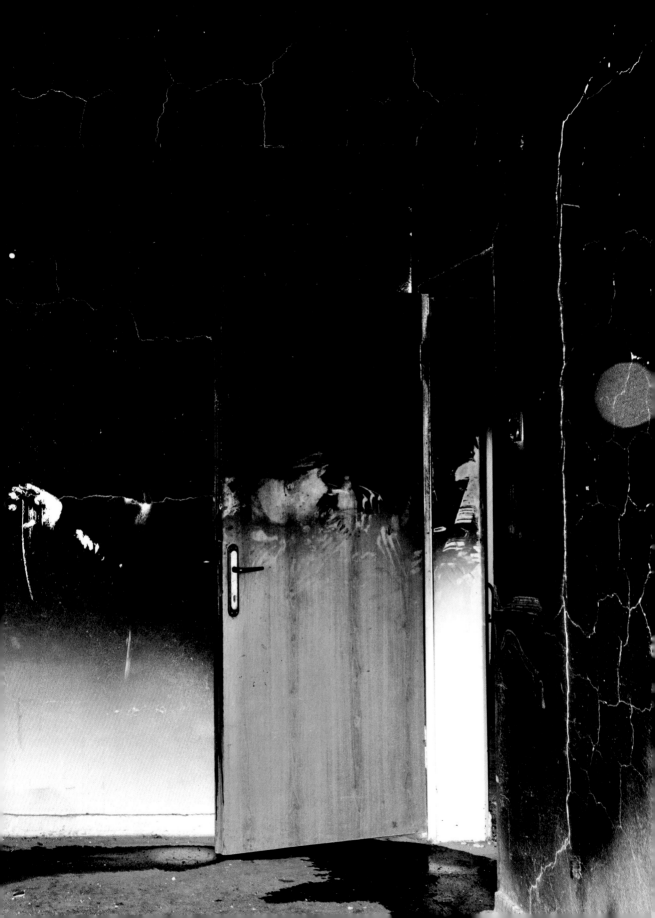

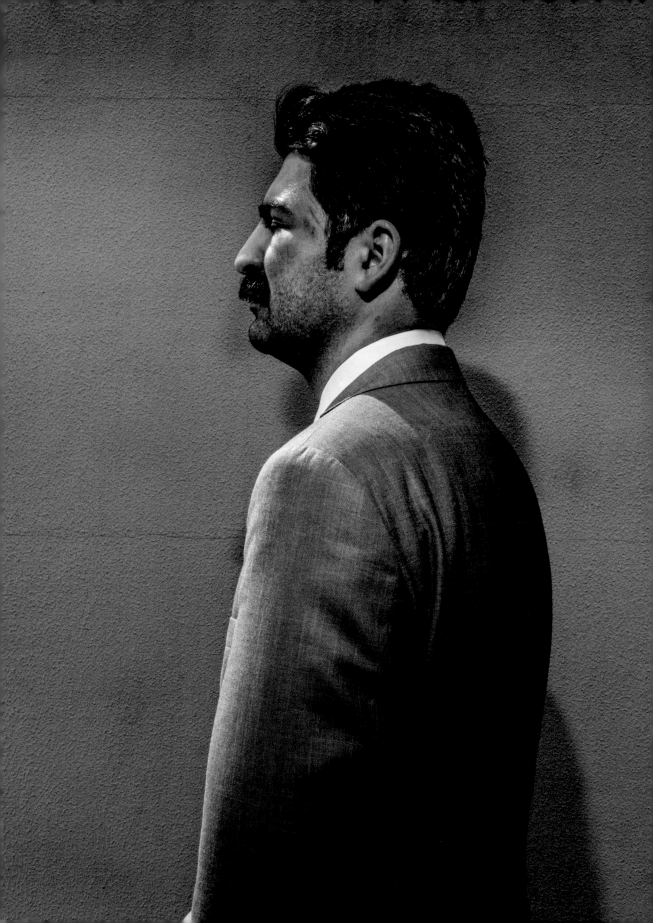

FATMA GİRİK
SERDAR GÖKHAN MERAL ORHONSAY
MAHMUT CEVHER

RENKLİ

MERYEM
VE
OĞULLARI

EROL EVGİN

YAVUZ SELEKMAN · ALİ SURURİ
BİRTANE GÜNGÖR · YILMAZ GRUDA

REJİ SENARYO: **OSMAN F. SEDEN**

KAMERA: **ÇETİN TUNCA**

CÜNEYT ARKIN

NİLAY YURTSEV **AHMET MEKİN**

NEJAT ÖZBEK
NEJAT GÜRÇEN

TUNCER NECMİOĞLU

VE **ZERRİN DOĞAN**

SÜHEYL EĞRİBOZ
RENAN FOSFOROĞLU

YILMAZ KURT
CEVDET
BALIKÇI
TEYFİK ŞEN

RENKLİ

1.TİCARETİM

YÖNETMEN
CÜNEYT ARKIN
SENARYO KAMERA:
FEYZİ TUNA **MUZAFFER TURAN**

AŞK
PARA YUMRUK

MEHMET KESKİNOĞLU
ÜNSAL EMRE · SEDEN KIZILTUNÇ

Prodüktör:
FETHİ OĞUZ

FUNDA FİLM
FETHİ OĞUZ

RENKLİ

ŞÖHRET BUDALASI

SEVDA FERDAĞ

OSMAN ALYANAK · MÜRVET SİM · ÖZCAN ÖZGÜR · NEHİR AKAR
ERSUN KAZANÇEL · MINE TUNÇ · MEHMET ALİ AKPINAR
RENAN FOSFOROĞLU · TARIK ŞİMŞEK · SEVDA SEREN
SÜHEYL EĞRİBOZ

Rejisör Senaryo
BİLGE OLGAÇ

KONU
BAŞAR SABUNCU

Foto Direktörü:
NEDİM AKANLAR

ŞEMSİ İNKAYA
BEN SANA YANDIM ZÜHDÜ

Funda Film

NİLGÜN CEYLAN OYA BAŞAR
SAMİ HAZİNSES

YÖNETMEN: **NURİ AKINCI** RENKLİ KAMERA: **MÜKREMİN ŞUMLU**

ZERRİN EGELİLER

TARIK ŞİMŞEK · TÜLİN TAN

ÇILDIRTAN KADIN

YÖNETMEN:
ÇETİN İNANÇ

KAMERA:
DİNÇER ÖNAL

SALİH GÜNEY
ZERRİN EGELİLER * SERPİL ÖRÜMCER

ALİ BABANIN
ÇİFTLİĞİ
MÜHÜR GÖZLÜM

NİLGÜN CEYLAN
FUNDA GÜRKAN

VE
**NERİMAN
KÖKSAL**

T.V. GÜLDÜRÜ SANATCILARINDAN
**CEMAL ÇOLAK
FATİH MÜHÜRDAR
JAKLİN YÜREK
EHAT ALİNÇE**

REJİSÖR: **SIRRI GÜLTEKİN**
SENARYO: **NURİ KIRGEC** KAMERA: **SUAT KAPKI**

MELEK GÖRGÜN

SALİH KIRMIZI

DOLGAN SEZER

YONCA YÜCEL

GÜLTEN KAYA

NİLGÜN CEYLAN

KURT KAPANI

KAMERA **ERHAN CANAN** SENARYO **RECEP FİLİZ**

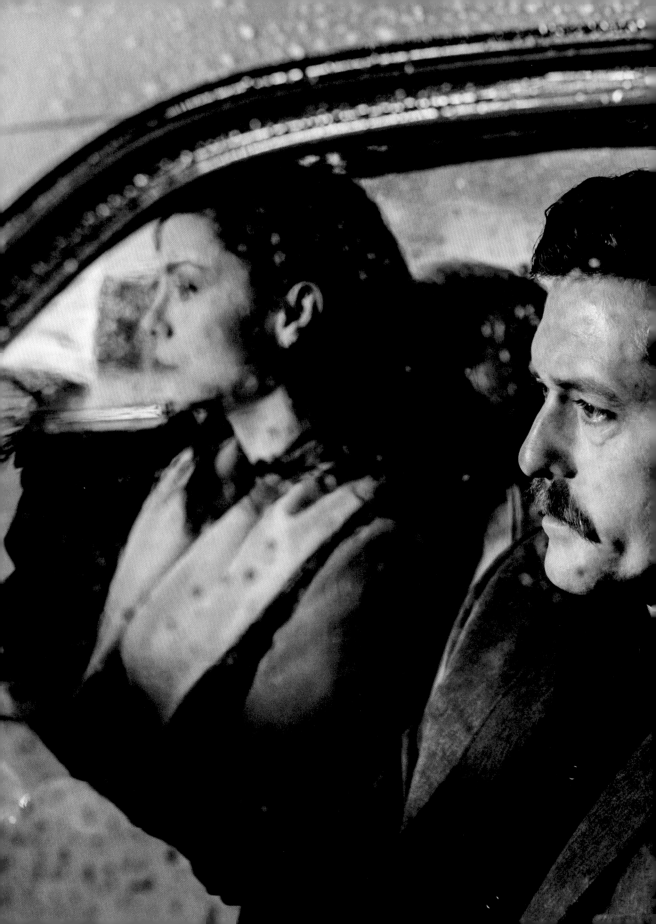

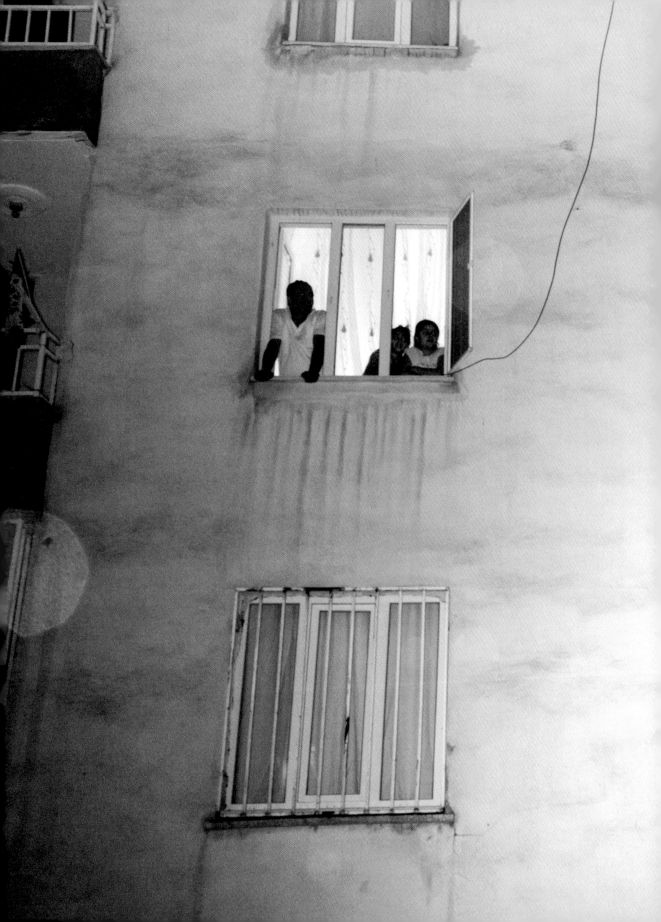

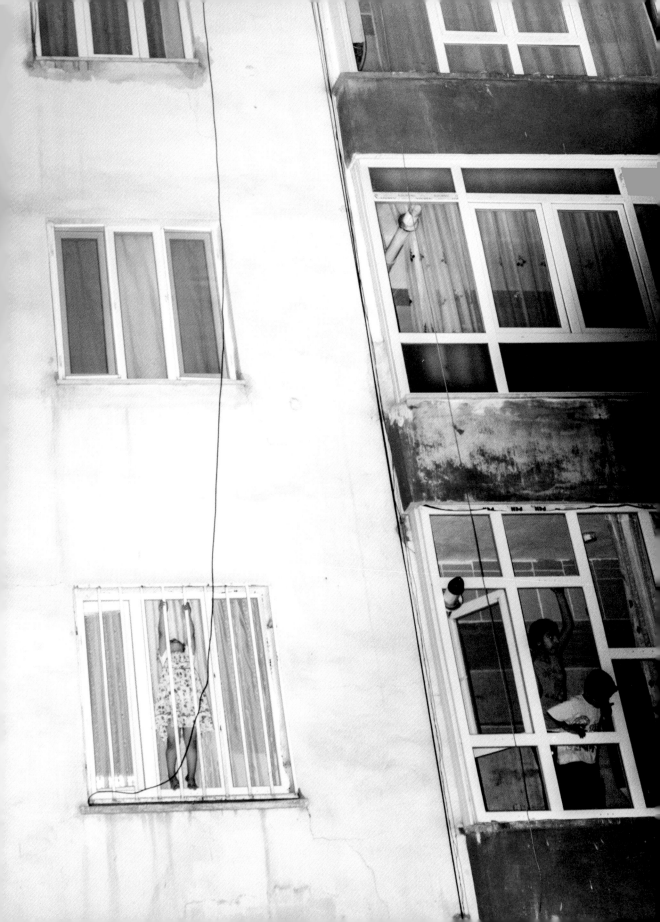

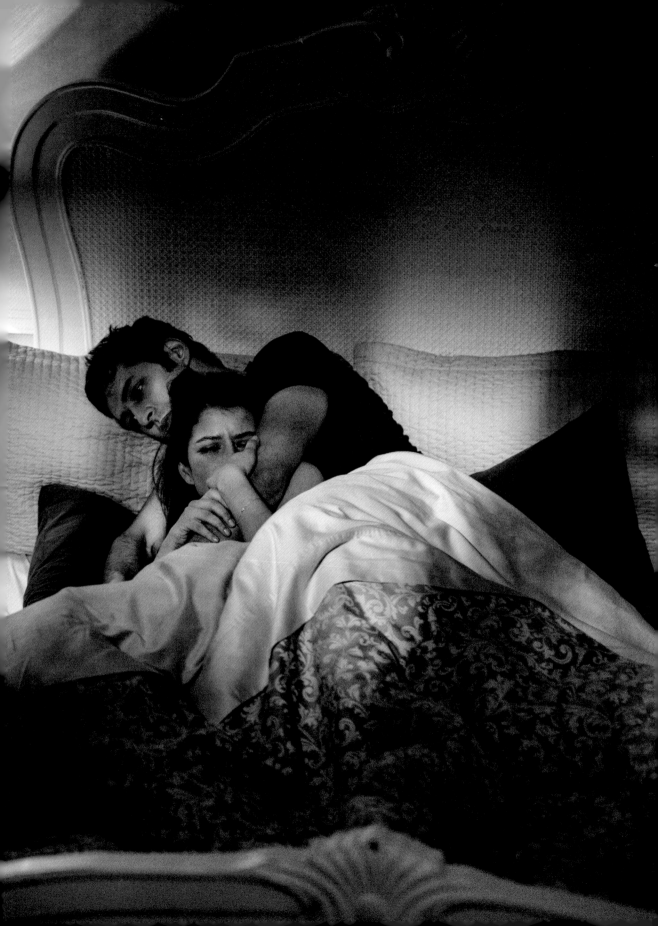

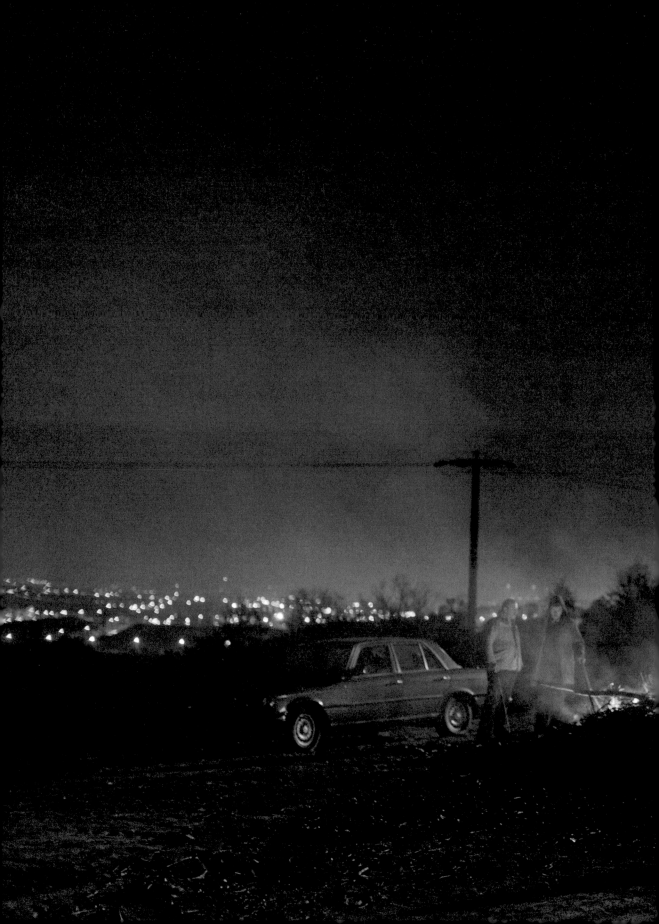

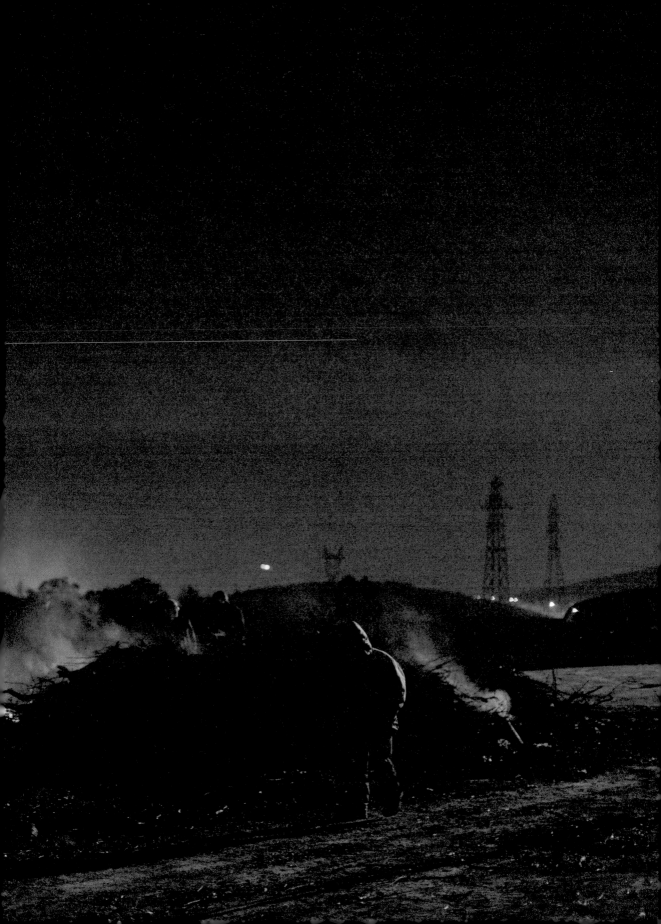

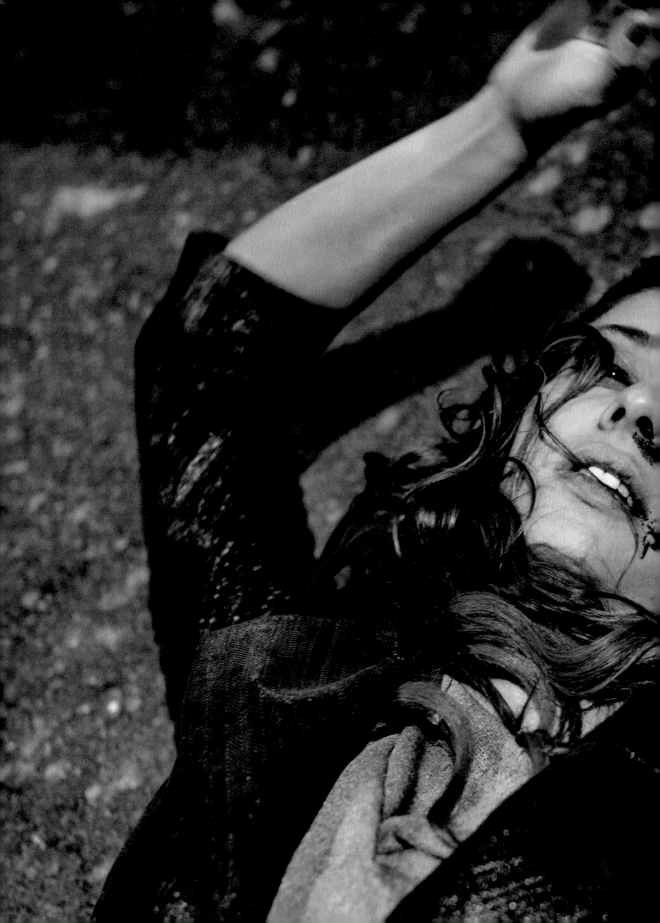

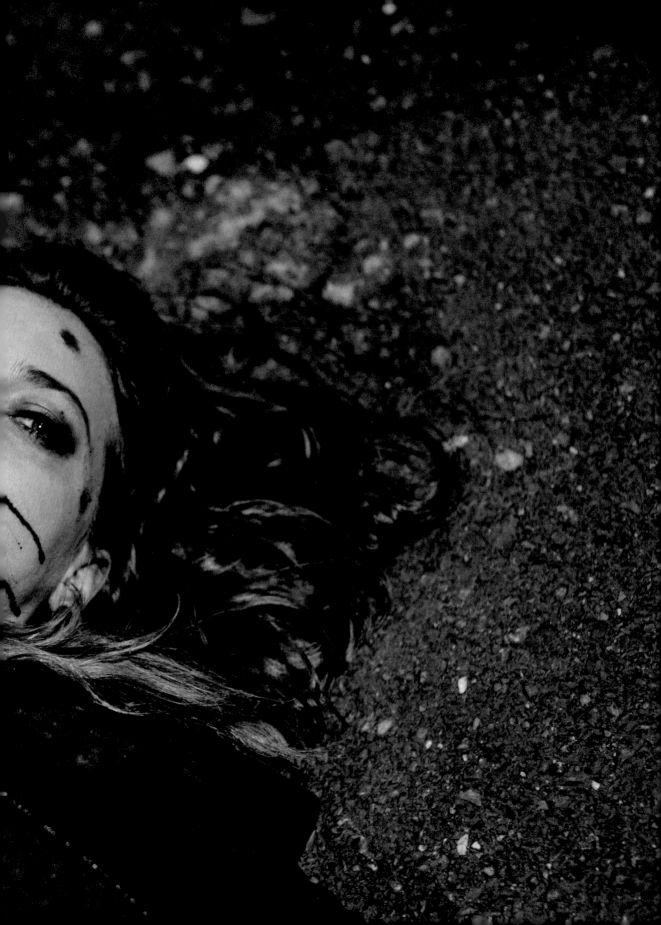

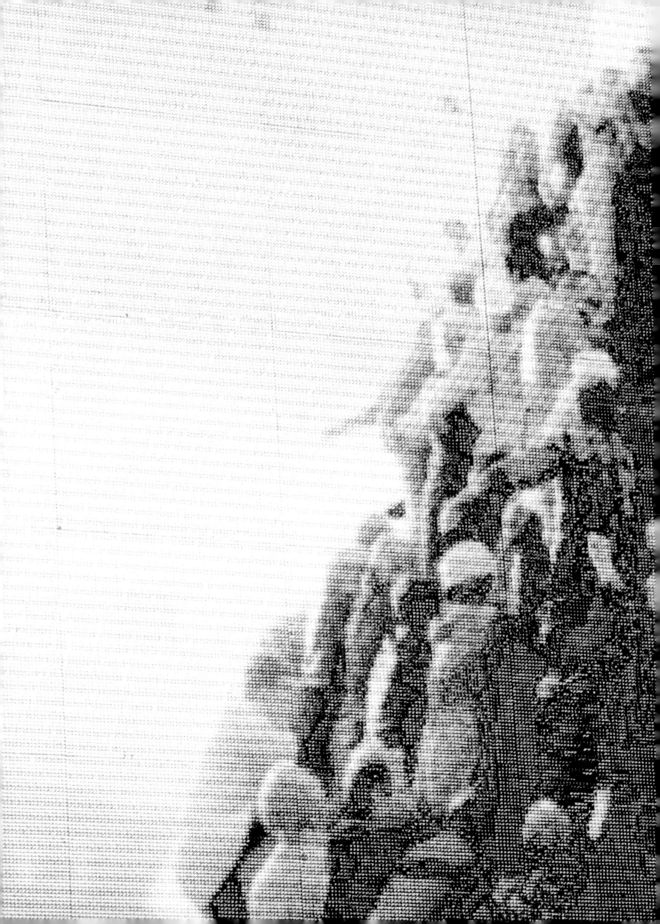

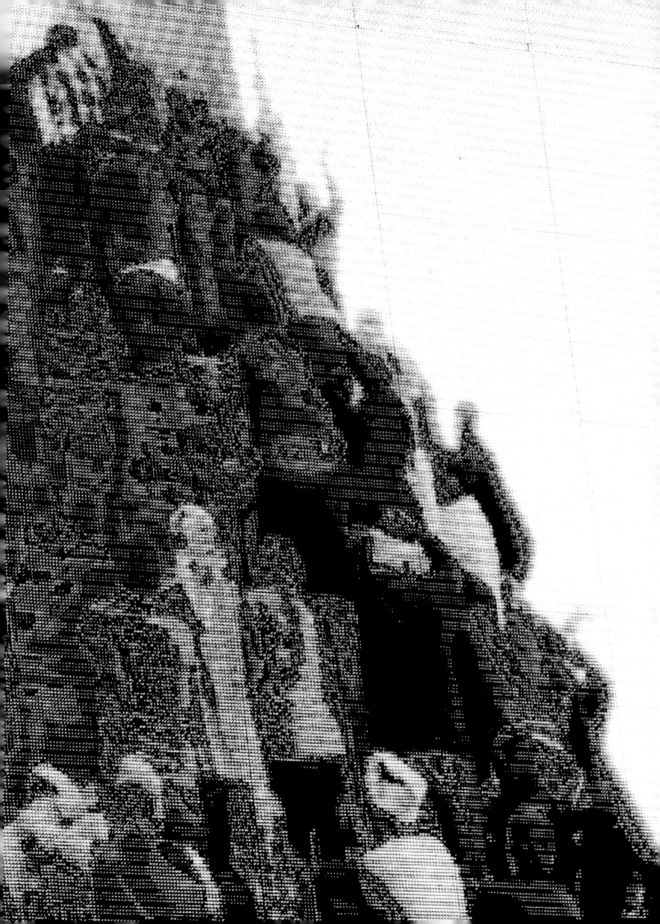

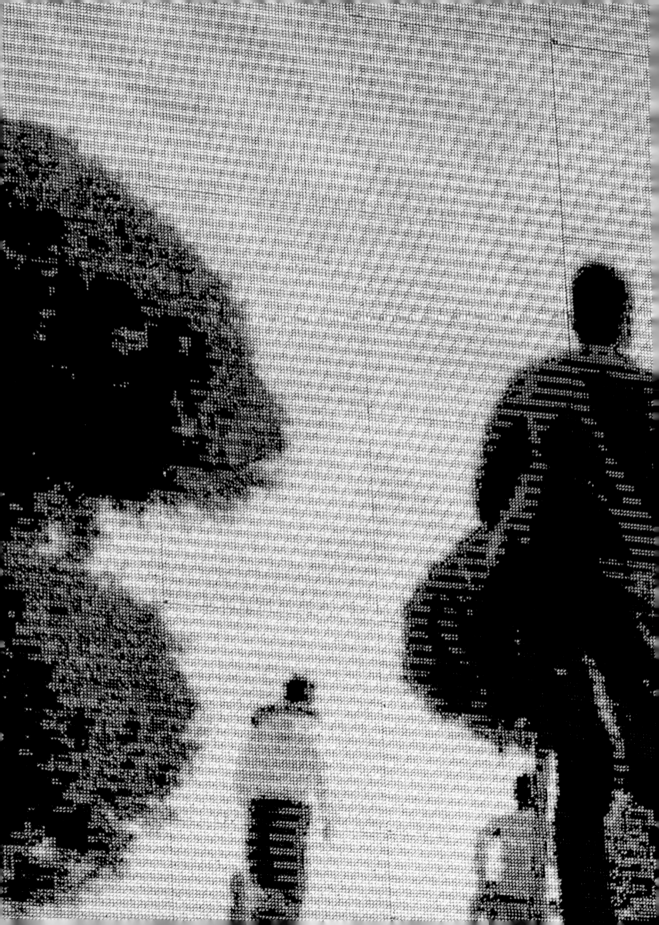

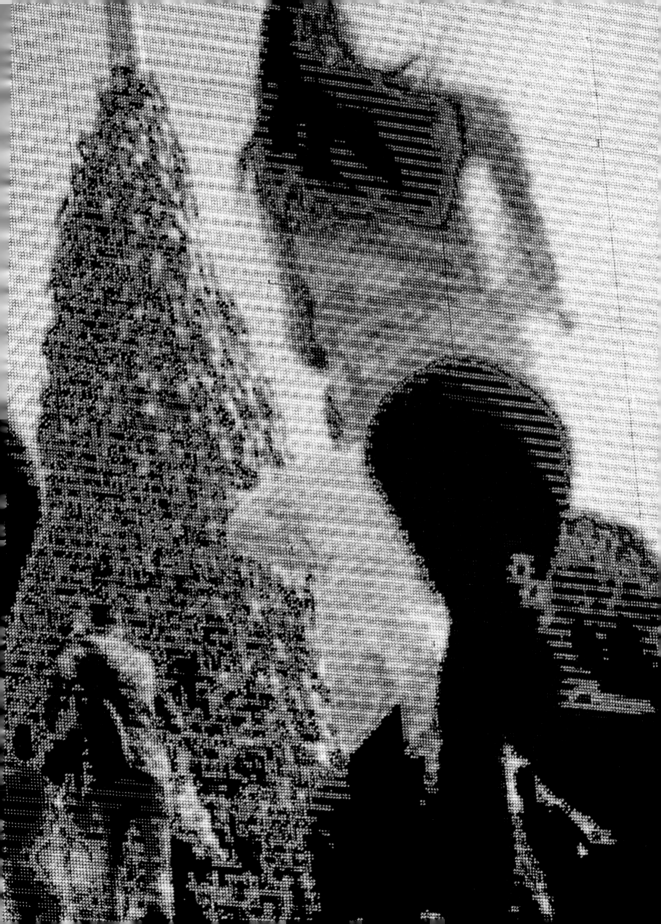

The Giant Who Slept Beneath Istanbul
Pelin Turgut

Once upon a time, there was a giant who slept beneath our fair and fabled city. Seven hills appeared where his shoulders sloped or knees bent and around the contours of his rather large head.

It was not so unusual back then to have a giant that slept underneath your city. They had a special task, these giants. Their job, you see, was to filter a city's bad dreams. That's why they were so big; to contain all the darkness they saw.

Human years meant very little to a giant. The giant who slept under Istanbul was little more than an adolescent, about 1675 years old. His was no easy task. This was a city destined to conquests and stormy seas, civilizations met, rose and fell on his breathing. Sometimes, it would all get a bit much for him and he would wriggle or fling a leg out. And though this was very rare, when it did happen, it caused no small amount of damage—bricks flew about, cracks the size of craters ripped through the streets and other strange things like ships that found themselves stranded miles inland from the sea.

It so happened that one day the city elected an ambitious young mayor. It was bad for business, this giant, he reckoned. His annual growth targets were constantly at risk, insurance premiums were through the roof and his city stood no chance in the great game of global commerce. Enough, he decided. He persuaded the city council that they no longer needed the giant to keep watch over their nights. Modernity had arrived. Progress was theirs. The giant belonged to a bygone era, better consigned to myth and legend. We can manage on our own, he declared. To which his people clapped and cheered.

A committee was sent to talk to the giant. The mayor took along an imam, and a rabbi, and a priest too, you know, just in case. Two school children came along, in grey and white uniform and well-polished shoes.

Everyone knew that the giant's ears were somewhere in the vicinity of Sariyer, up in the hills towards the Black Sea. The water always ran cool up there, chilled by the giant's rhythmic breaths. If you stood inside one of the caves at the top, and whispered, so the story went, the giant would hear your prayer.

So it was that this odd collection of people—the mayor, the imam, the priest, the rabbi, and two children—climbed that hill, entered the biggest cave and sat down. The cave rumbled to the giant's rolling snores.

Ahem, ahem, coughed the mayor. No response. Ahem, ahem, he repeated. Dear Giant Sir. (He was a little nervous). We are the bearers of good news, he said. The city has prospered. We have done well. We have banished wild wolves, gypsies and bad plumbing from our city. We no longer need a giant to keep watch over our dreams. There is a new city being built, some 50 kilometres down the road, and they could really use your services. So, um, thank you very much for services rendered and all that—I have a certificate right here for you—but it's time for us all to move on.

Silence. They knew the giant had heard, because there was no more snoring. But still no response came. So they sat and waited. The giant knew nothing of human time, that much they knew. The children sang a gusty rendition of *Ode to Progress* and other marching tunes. They ate *dolma*

and too many cheese-stuffed *borek*, fell asleep and woke up to boil tea on the portable gas stove they had brought along.

Eventually, as dusk fell, the giant sighed. OK, he said. I won't stay where I'm not wanted in any case. (He was a young giant, you recall, and hence sensitive). I'll go. Just don't wake me. I can't seem to get enough sleep as it is. I'm awfully tired. He yawned, the cave walls shook, and the party tripped over each other in their hurry to get out.

It was a huge operation. Students from the faculty of engineering planned it for weeks in advance. Ten tankers shrouded in dark cloth were joined together in a flotilla to transport him away. The giant left, eyes tightly shut. Builders and diggers from many miles surrounding rushed to fill in and shore up the spaces left by his hefty body.

Life returned to normal.

But things soon began to unravel. With no giant to contain them, an entire city's nightmares began to spill out into the nighttime air. Random killings began. Money disappeared. Children got sick with diseases doctors had never heard of. People began to dread watching the evening news.

Though at first, nobody made the connection between the giant leaving and the city's troubles, after a time, protestors began gathering in front of the mayor's municipal building. They were students and poets, punks and young mums pushing prams. Bring the giant back! they demanded.

The mayor was furious. Sending the giant away had been the highlight of his career. These people were backward and ignorant, he pronounced. They wanted to send the city back to the dark ages. He grew so incensed by the crowds outside his office that it wasn't long before he unleashed great violence. He sent in tanks and men with gas and guns. People were arrested, some were jailed for months on end. A dark cloud settled over the city, mixing with its polluted fumes.

The protestors, however, were a determined lot. Their numbers included a wise old man who knew what had to be done, for he had heard it foretold by his father, who had heard it from his father before him. He knew this day would come and he had spent a lifetime preparing for it.

A small and colorful band of people came to see him off. Singing and clapping, they watched as he climbed the hills above Sarıyer. When he came to the fountain, he filled his bottles, and when he came to the cave, he bowed his head and went inside.

He spread his sheepskin, sat down and crossed his legs.

To you or I, it might have looked as though he was just sitting. But ah if only you knew what he saw—no matter how brave he might be, he was just a teeny tiny human being, and the evils he saw almost killed him. He wept until his tear ducts dried up. He writhed on the cave floor and bit his nails to their core. And eventually, he lost hope. Seized by despair, he began to think he would never see his home again. Doubt began to eat away at him.

Just when he thought he could not possibly bear another moment, from so many miles away, the giants who kept watch over human destinies stepped in. For they had promised that they would always come to the aid of any two-legged creature brave enough to sit through a dark night on his own. The old man never knew just how it happened, but a sudden breeze blew through the cold cave, an ocean of calm swept over him and his old heart, so tremulous before, found new life and rhythm. The giants, whom he could not see, made sure his limbs were massaged and eased his wrinkled forehead.

His trials were not over, of course. Mischievous demons came forth this time—they offered him grapes, ripe and bursting at the skin. You seem hungry, they said, have one. And their voice was as sweet as a bubbling brook in spring. And he was indeed starving. But he knew about these grapes; just one taste would send him back into the deepest slumber. So he continued to sit, eyes closed, a gentle smile on his lips. Naked girls appeared and surrounded him. Come play with us, they whispered, pale hips shimmying in the dark. Everyone deserves a little break. Come lie down for a short while, they said. How he was tempted! It had been so many years of lying alone since his wife had gone. They smelt so sweet. His limbs grew heavier and just as he was about to succumb, with the last of his strength he grasped his wooden staff and hammered it on the ground. Three times: tap, tap, tap! And the girls vanished.

Thus did 40 days and 40 nights pass. The moon waxed full and waned again and one evening at dusk, as it appeared a thin sliver in the sky, the old man flew out of the cave, still cross-legged. Though thin he was very much alive. He stood up and walked slowly down the hill to the group patiently waiting for his return. He smiled at them and passed along the wooden staff to the next person in line, a math teacher at a local primary school.

And so it went, from the teacher, to a ballerina, then a carpenter. They were ordinary people, just like you and me. People you might sit next to on a bus or wait in line with at the corner store. That was the chain, and that's how it still goes. There is always someone sitting there, in that cave.

In time, the city grew calmer and a strange thing started to happen. The bad dreams grew dimmer. As they receded, into the space they vacated came flooding something tremendous and new. The city's inhabitants began to dream dreams of great beauty and wonder. The air grew cleaner. It rained and the river began to flow again. Fish returned. Birds and wolves too. Great songs, which they had never heard before, began to float through this beautiful city of theirs. Seeing this, from far far away, the giants smiled and they rested.

A Matter of Perception
Piotr Zalewski

In Turkey, the end of reality began at a political rally in Diyarbakir, a city in the country's Kurdish southeast, under blue skies and a scorching sun in June of 2015. Local folk songs washed over a boisterous crowd. Women danced, shimmering in dresses studded with green, yellow and red sequins. Near the stage, separated from a throng of thousands of people by two rows of blue police barriers, an elderly farmer chewed on sunflower seeds, awaiting the show's main attraction, Selahattin Demirtaş, the telegenic, bright eyed leader of the Peoples' Democratic Party (HDP), the flagbearer of the Kurdish political movement. His village was a good eighty miles from Diyarbakir, more or less halfway to the Syrian border, the farmer said, but this, the HDP's last big rally ahead of the most important Turkish election in more than a decade, had been worth the drive.

No group claimed responsibility for the two explosions that ripped through the crowd moments later, sending hundreds of people, including the man with the sunflower seeds, running for cover, and leaving four lifeless bodies in their wake. Many Kurds blamed Turkey's president, Recep Tayyip Erdoğan, who had accused the HDP of receiving support from homosexuals, terrorists, and Armenians, for the attack. A few media outlets close to the government suggested that a militant group, the Kurdistan Workers' Party (PKK), was to blame, and that it had staged the bombing to attract sympathy votes for the HDP in the upcoming elections. Days later, police arrested a young Islamic State (IS) militant, himself a Kurd, who confessed to planting the two bombs. His was the opening salvo. Over the following year, dozens of other attacks, including the five deadliest bombings in Turkish history, rocked the country, killing hundreds of people. A thirty-year war between the PKK and the government stormed back into the southeast, taking thousands of lives and turning whole neighbourhoods, including parts of Diyarbakir's historical district, into mounds of rubble. A coup attempt left scores more dead in a single night, shaking the country to its core. An ensuing crackdown, having spread from one area of public life to another, cost more than 50,000 people their freedom, from soldiers to judges to teachers to journalists to Demirtaş and other Kurdish MPs. Under emergency rule, more than 110,000 others were sacked from government jobs. Reports of torture spread. There seemed to be no end to the repression in sight, and still less room for dissent with every wave of arrests. With Erdoğan at the reins, Turkey kept on galloping, breathless and dazed, into the unknown.

The chain of events that began with the Diyarbakir bombing also claimed a less conspicuous victim—the truth. Politics and the media in Turkey have always been plagued by disinformation and conspiracy theory. Since that summer day, though, rhetoric, abetted by censorship, repression, and nationalist paranoia, has suffocated reality. Brought to heel by Erdoğan's government and by media tycoons dependent on its largesse (or too scared to rub it the wrong way), the press has transformed from a buffer against official spin into the tray on which it is served. Wide swathes of the internet are off limits. Wikipedia has been blocked since the spring of 2017. In Europe and the US, people have begun to talk about 'post-fact' politics. In Turkey, the facts themselves are on the verge of extinction.

In their stead, the government and its media have coined their very own

newspeak. Market forces responsible for the recent economic downturn, including the collapse of the Turkish lira, are called the 'interest rate lobby.' Western powers, routinely blamed for the unrest which consumed Turkey over the past years, are known as the 'superior mind,' the 'chaos lobby,' and the 'crusader alliance.' The global conspiracy against Turkey is the 'game.' Publicists, academics, activists and even cartoonists who criticize the government have been referred to as agents of 'intellectual terror.' Government policy is the 'national will.'

My favourite of the bunch is also the one that perfectly captures the schizophrenia gripping Turkey today: algı operasyonu, or 'perception operation,' a phrase used by cabinet ministers, media apparatchiks, and state prosecutors, much as Donald Trump uses 'fake news,' to cast doubt on practically anything that fails to square with the official narrative, be it a critical news story, an unflattering cartoon of the president, or an unexpected, unwelcome development. 'Perception operation' is not so much an insult to people's intelligence as to their capacity to distinguish between fiction and fact.

What you see with your own eyes is only half as important as what you are told to believe. In May of 2016, a lone gunman tried to shoot Can Dündar, a journalist charged with treason for documenting secret arms shipments to Syria by Turkey's intelligence agency. Leading pro-government newspapers claimed that the shooting was choreographed. 'Theatre' they called it. Months later, a Turkish police officer gunned down Russia's ambassador to Ankara inside an art gallery, shouting Islamist slogans. The assassination, the city's mayor immediately claimed, was an act of 'perception management.' When Islamic State released a video showing its militants burning alive two Turkish soldiers, something no mainstream outlet has been allowed to report, one pro-government journalist claimed the recording had been made in movie studios in America and the UK.

In America, the worst that a hard-hitting news story might cost you, at least for the time being, is an angry, misspelled tweet from the 'Real Donald Trump.' In Turkey, it can cost you your freedom. Since the 2016 coup, over a hundred reporters, columnists and other media professionals have been thrown behind bars. Erdoğan's government insists this had nothing to do with their journalism. The formal charges against them show otherwise. The bulk of the evidence against Dündar and eighteen of his colleagues from Cumhuriyet, an opposition newspaper, consisted of their writing. Dozens of others were accused of 'attempting to overthrow the constitutional order' through articles and media statements. The phrase 'perception operation' appeared in their indictments on at least ten occasions. The Cumhuriyet journalists were handed prison sentences of up to seven and a half years and released pending appeal. Two writers and a veteran columnist arrested for sending what prosecutors referred to as 'subliminal messages' against the Erdoğan government ahead of the coup were sentenced to life.

In much of the 'free world,' the media and state institutions have only recently started constructing defences against 'alternative facts' and the like. In Turkey, those defences, and the border separating reality from fiction, have already collapsed. In Europe and the US, fake news comes from the margins, from Russian troll farms, and from those on the far right and the far left. In Turkey, it comes from the mainstream, rolling off the pages of top selling newspapers and the tongues of elected officials. When homegrown

IS militants first struck the country, government ministers alleged they had received assistance from Kurdish insurgents—a claim as unsubstantiated as it was preposterous, given that the Kurds had lost thousands of fighters and civilians in battles against the jihadists in neighbouring Syria. In the weeks that followed the coup, pro-government media claimed that a group of American and Turkish academics directed the bloodbath from an island on the Marmara Sea, where they happened to be attending a conference (several of them have been indicted). A cabinet minister blamed the coup on the Obama administration. Erdoğan, who blithely ignored the spread of jihadism in his own country, repeatedly accused the West of supporting IS forces. His media allies blamed America for a terrorist attack at an Istanbul nightclub. A month later, the mayor of Ankara, he of 'perception management' fame, accused it of setting off a series of earthquakes. American audiences got a taste of the Turkish government's relationship with reality, and with dissent, earlier this spring when several armed men beat up Kurdish and Armenian protesters outside the Turkish embassy in Washington while Erdoğan was in town. Without batting an eyelid, the embassy responded to the thuggery by condemning the protesters for holding an illegal gathering and provoking 'peaceful Turkish-Americans' who had come out to welcome their leader. The protest turned out to be perfectly legal. Some of the peaceful Turkish-Americans, who were recorded kicking some of the protesters as they lay on the ground, turned out to be Erdoğan's bodyguards.

Part of the trouble with conspiracy theories in Turkey is that they are so widespread that they have begun to replace the reality they misrepresent. The other part is that the conspiracies they describe sometimes turn out to be real. On July 15th 2016, the night of the most violent coup attempt in Turkey's history, a few of them sprung to life, larger and more terrible than anyone could have imagined. Army tanks roared across Istanbul's Bosporus bridge. Fighter jets seemed to graze the tops of buildings in the city centre, setting off sonic booms that shattered windows and blew open doors. On at least two occasions, our old apartment building shook so violently that my wife and I mistook the booms for explosions. In Ankara, the warplanes did strike, dropping bombs on a police headquarters, parliament, and on civilians gathered near Erdoğan's palace. Soldiers mowed down unarmed protesters. Tanks trampled cars, and the people inside them. By the morning, the coup had been thwarted. 270 people were dead in its wake.

As told by the Erdoğan government, the story of what happened that night resembles an Ian Fleming novel invaded by the script of *The Body Snatchers*. Facing conspiracy charges, a shady Turkish preacher, Fethullah Gülen, flees to America in 1999, leaving behind tens of thousands of followers. In exchange for safe haven on a farm in the Poconos, Gülen agrees to work with the CIA. Seventeen years later, encouraged by his minders, the Obama administration, or other Western governments, or all three, he gives the go ahead for an armed putsch against Erdoğan. Like zombies, members of the Gülen brotherhood in the army awaken, attempt to seize control of the country, occupy official buildings, hold the chief of staff hostage, and dispatch a hit squad to arrest or assassinate Erdoğan. Thanks to crowds of people who brave bullets and tanks to defend Turkish democracy, the coup flounders.

So spectacular and gruesome was the violence, and so well did it play into the hands of a leader who had long sought to tighten his grip over the country, that many Erdoğan opponents believed that the whole affair had

been staged—a perception operation perhaps. The morning after the bloodshed, drowsy and sleepless, the sound of explosions and gunfire still fresh in our ears, we wandered over to a local restaurant to grab eggs and coffee. The waiters and some of the patrons were watching a TV mounted near the entrance. Onscreen, soldiers who had taken part in the coup were surrendering to police. The evening before, after news of the coup broke, the neighbourhood convenience store and the ATM outside our house had been under siege by locals stocking up on cash and basic supplies. Today it was as if nothing had happened. The sun was out. Our grocer was petting a stray dog. A man was selling sesame seed bagels. And because the scene needed to feel even more absurd and even more ordinary at once, a woman in a white bridal dress and a man in a tuxedo, flanked by family and friends, sauntered into the restaurant, walked past the TV and the police and the soldiers, and took a seat in the back. I went over to talk to them. They said they had made two decisions when they woke up that morning. The first was to go ahead with their wedding, which they had been planning for months. The second was to leave Turkey. The groom's mother weighed in. 'This was no coup,' she said confidently. To her, as to the government supporters who had made light of Dündar's shooting two months earlier, events that refused to conform to preconceived narratives had no right to take place. 'This was theatre,' she said.

It was not. Parts of the government's account of the coup might be mindboggling, but they stand up to scrutiny. Gülen does appear to be the most plausible culprit, by a longshot. Security footage and witness testimony show that the cleric's associates certainly played some role in the coup. Five civilians who spent the night of July 15th inside the airbase that had served as the coup headquarters turned out to have links to the brotherhood. Two of the men turned out to have travelled to JFK Airport, a couple of hours by car from Gülen's residence in the Poconos, on the same flight four days ahead of the coup, and to have returned, also on the same flight, two days later. The brotherhood had the resources to attempt a state takeover, and its reasons to do so. Over the years, its followers had burrowed their way into the upper echelons of the bureaucracy. Gülenist policemen and prosecutors hounded the group's enemies, sending hundreds of secular army officers to prison, often on the basis of forged evidence. The movement's supporters in the military moved up the ranks unobstructed. Erdoğan first referred to a Gülenist 'parallel state' in 2013, when police and prosecutors began rounding up some of his cronies and confidants on bribery charges. Ever since, he has cried wolf so many times, blaming the Gülenists for everything from mass protests to nepotism and corruption in his own party, that many of his critics, as well as more than a few outsiders, dismissed the notion as the product of a paranoid mind. The coup proved him at least partially right. The 'parallel state' turned out to be real, and more dangerous than anyone had imagined.

Much of the rest is a fairy tale. There is no evidence to suggest that Western countries supported the coup. Also, Gülen followers did not infiltrate the army, the police, and the judiciary, as the government maintains. They were handed the keys. For a decade, Turkey's ruling Justice and Development Party (AKP) showered Gülen followers with government jobs, promoted Gülen businesses, and backed show trials choreographed by Gülenist prosecutors and judges. Theirs was a coalition of Islamists determined to wear down the secular establishment, including the army. It came apart at the seams, and

descended into a blood feud, only when the same prosecutors went after Erdoğan and his ministers.

Today, Erdoğan's government seems much less concerned with uncovering the conspiracy behind the July 15th coup than with placing the entire blame for it on the Gülenists. The pursuit of justice has taken a back seat to the pursuit of revenge. Of those who ended up behind bars or out of a job, most were targeted on the basis of evidence that would have been laughed out of any respectable courtroom. No proof exists that the thousands of judges, prosecutors, doctors, academics and journalists imprisoned over alleged Gülen links played any role in the coup. Tens of thousands of people were detained simply because they had downloaded a messaging app allegedly used by the Gülenists. Thousands more were sacked for having accounts at a bank managed by Gülen followers. Over a hundred academics were indicted on terror charges because they signed an open letter calling on the government to suspend security operations against PKK militants. The evidence against an American pastor, Andrew Brunson, arrested in late 2016 on charges of espionage and links to terrorist groups, included a photograph of a dish of meat, rice, and fried vegetables, a meal said to be favoured by Gülenists. Scores were arrested after being found in possession of a $1 bill, supposedly a mark of membership in the group of soldiers involved in the coup. In the trial of a Turkish-American NASA scientist, prosecutors presented a dollar bill found in the defendant's home as key evidence. The man was sentenced to seven and a half years in prison. Even the claim that it was Gülenists inside the army who coordinated the violence rests on uncertain ground; most of the arrested officers have denied ties to the movement. Turkish officials continue to say that Fethullah Gülen personally ordered the coup. Compelling as the idea might be, they have failed to produce any incontrovertible evidence supporting it.

If they see no need to do so, it is because the facts in Turkey are increasingly what the government wills them to be. The cowed judiciary, a fourth of its members suspended or behind bars, resembles an extension of the executive. The secular opposition is paralyzed. The Kurdish one is in prison. To protest the crackdown, to expose the human rights abuses that have multiplied over its course, is to invite accusations of complicity with the Gülenists, and to risk sharing their fate.

In such an atmosphere, it is the narratives that matter, and not the facts. The middle ground has collapsed. Some Erdoğan opponents continue to claim, mostly behind closed doors, that July 15th was an inside job, or a controlled coup. The government keeps on stamping out any version of events at odds with its own. On the first day of school in 2016, it provided Turkish schoolchildren with brochures describing the coup as an attempt by Western powers to occupy Turkey. The year after that, it added a course on July 15th to the curriculum. Countless schools, stadiums, tunnels and swimming pools, as well as the Istanbul bridge where soldiers and tanks shot at protesters, have been renamed after the coup and its victims. The Gülen movement is no longer referred to as such, but as the Fethullah Terrorist Organisation, or FETO, the name decided on by the government. The alliance between the Gülenists and the ruling AKP party, which lasted over a decade, is being erased from memory.

Most of the media, now in the hands of businessmen dependent on Erdoğan's largesse or too scared to rub the government the wrong way,

has surrendered to the new truth. Open your average newspaper, and you will learn that Europe hates Erdoğan because of the airports, the metro stations, and the bridges built on his watch, that the Kurdish opposition is indistinguishable from an armed terrorist group, that the secular opposition is in cahoots with the people responsible for the 2016 coup, and that European powers want to invade and divide Turkey. You might also read that an American investigation into sanctions busting by a Turkish bank is nothing other than a new attempt to topple the Erdoğan government. Turn on the television, and you will see that no civilians were killed, or even harmed, in a spring 2018 offensive against Kurdish insurgents in Syria, and that hundreds of people detained for suggesting otherwise, or for calling for peace, are in fact traitors or terrorists. Keep watching, and you will hear that galloping inflation and a currency crisis, which no one in Turkey can refer to as such, are not the product of loose monetary policy and a credit binge, but of attacks by foreign enemies. You can laugh when government officials peddle such drivel. When the media report it uncritically, you can start looking for a good therapist. With each new coating of propaganda and conspiracy theory, reality here fades further from view. Turkey has been losing its democracy for some time. Now it risks losing its sanity.

The Parallel State
Guy Martin

Fascism says nothing's true, your daily life is not important, the facts that you think you understand are not important, all that matters is the myth—the myth of one nation that's together, the mystical connection with the leader. When we think of post-truth, we think it's something new ... actually what post-truth does is it paves the way for regime change. If we don't have access to facts, we can't trust each other. Without trust, there's no law. Without law, there's no democracy. So, if you want to rip the heart out of a democracy directly, what you do is you go after facts. And that's what modern authoritarians do.
Timothy Snyder, author of *On Tyranny*. Excerpt from The Daily Show appearance, 2017

'The parallel state' is a term hijacked by Turkish president Recep Tayyip Erdogan and turned on its head, a rebranding, essentially, of the better-known 'deep state.' The modern Turkish deep state origins lie in the early days of the cold war when clandestine 'stay behind' units formed the foundation for a resistance movement in the event of an invasion and occupation by communist forces. These forces were collectively called the OHD (Special Warfare Unit) and its members were all highly trained in intelligence gathering, tradecraft, assassination, sabotage, propaganda and other covert activities to destabilise a hostile regime. The communist invasion never came, but throughout the next sixty years, these units morphed and integrated into the police, judiciary, civil service, military and media.

As Tayyip Erdoğan rose to power from the early 2000s, he was increasingly, and sometimes rightly, convinced that he was being undermined by followers of his former ally, Fethullah Gülen, currently in self-imposed exile in Pennsylvania. Gülen, a cleric and preacher of a more moderate, inclusive and scientific form of Islam, fled Turkey in the late 1990s fearing arrest from the military rulers at the time. By 2012 Gülen's followers—now numbering in the millions—had infiltrated every institution within the Turkish State. To supporters of Erdoğan, this secret politicised, bureaucratic cabal, were all part of a traitorous 'parallel state' that could and would be blamed for any of Erdoğan's mishaps and Turkey's ills.

A once uniquely Turkish phrase, 'the parallel state' has become a byword for power grabs, populist rhetoric, and a police state on the hunt for an unfixed yet ever-present enemy, recalling Western politicians' endless invocations of 'terrorist' forces at work. With factious political movements on the rise from the United States to the United Kingdom and beyond, the work has taken on a particular potency in its focus on Turkey as a model for the ways in which authoritarianism might be sewn almost imperceptibly into the fabric of a society; the deliberate shattering of citizens' sense of security, community, and ability to distinguish between fact and fiction ensures only one state-approved narrative prevails.

The Parallel State encompasses the idealistic Gezi Park protests of 2013 to the failed coup attempt in 2016 and subsequent purges—the government's crackdown on suspected adversaries. Intermixed with photographs of those cataclysmic events are images from the sets of Turkish soap operas, houses of mirrors in which the country's recent past occasionally comes into view.

TV shows that previously exported a simultaneously nostalgic and socially progressive vision of Turkey across the Arab world—with tales of sultans, harems and star-crossed lovers—have since refocused their storylines to emphasize Turkish military and political power plots by deep state operatives, collusion by foreign powers, and terrorist attacks by the Kurdish PKK and Islamic State.

As social media assumes an increasingly influential role in contemporary conflict, new 'virtual battlefields' on mobile, computer and television screens have become as relevant as the physical ones. *The Parallel State* strives to address the complexity of capturing 'authentic' moments while confronted with media-conscious subjects acutely aware of how to stage a narrative for easiest consumption.

Acknowledging the danger in any individual claiming the status of 'truth-teller,' *The Parallel State* serves as a timely vision of how authoritarianism thrives in a society plagued by doubt and divisive falsehoods, segregated into heroes and villains, and deprived of access to facts.

The Martyrs

At a raucous televised congress of the AK Parti (Justice and Development Party) in the southern town of Kahramanmaraş, President Recep Tayyip Erdoğan was asking the crowd for support of Turkish troops in on-going military operations. A six-year-old girl dressed in military uniform suddenly caught his eye and he called out to her, 'Look, look, look, what is there? Girl, what are you doing there?'

The young girl, giving a military salute, stood ramrod straight in the audience, but her lips were trembling. Erdoğan's aides scrambled to help the girl through the crowd to the stage.

'We have our maroon berets here, but maroon berets never cry,' he said, referencing the uniform worn by the Turkish Special Operations Forces fighting Kurdish YPG units in Syria's northern Afrin Region. His supporters cheered loudly, 'Chief! Take us to Afrin!'

The girl, by then in a flood of tears, stood stunned next to the President, who kissed her on both cheeks.

'She has a Turkish flag in her pocket too … If she becomes a martyr, God willing, she will be wrapped with it' he continued, 'She is ready for everything, isn't she?'

The girl replied, 'Yes.'

The President then kissed her face again and let her go. He continued his speech at the congress rally, promising to protect Turkey's borders and crush terrorism. He recited Turkish poetry—conjuring glories of Turkey's past, listed the number of enemies killed, and asked the crowd to send prayers to families of recent martyrs.

The Kittens

Adnan Oktar is the most notorious cult leader in Turkey. Beginning in the 1980s, the Muslim creationist introduced the world to his bizarre take on Islamic religion—including his fierce opposition to the theory of evolution—when he published his book *The Atlas of Creation*.

Oktar refers to his cadre of devoted women as 'kittens.' At his behest,

the 'kittens' shirk hijabs and traditional dress. Instead, they wear designer outfits, apply heavy makeup, and undergo plastic surgery. They also happen to be wealthy socialites. Oktar's televangelism is a bewildering spectacle that challenges normal expectations of what the Islamic debate should be and has sparked ridicule and indignation in equal measure. Critics call his broadcasts 'a sexed-up Disney version of Islam.' But what makes his shows so unique is the way he manages to use sex as a device to preach theories on Islam. Cosmetically enhanced, platinum-haired women swoon around him and refer to him as 'master,' while wearing tight t-shirts emblazoned with phrases like *I read the Quran.*

Oktar and his followers are trying to usher in what they call the new face of modern Islam. With their own TV network, A9, they broadcast their views and through the network's publishing arm, Oktar has published over 300 books, all written under his pen name, Harun Yahya. Many of the books argue that Darwin's theory of evolution is at the root of global terrorism.

On the morning of 11th July 2018, Oktar and 155 of his 'kittens' were arrested by officers from the financial crimes branch department of the Turkish Police. The charges put against them included the formation of a criminal gang, tax fraud, terrorism and sexual abuse. Ammunition and more than fifty guns were seized during the series of raids. Before being led away in handcuffs, Oktar told journalists that the allegations made against him were lies and 'a game by the British deep state.' He added', ... British intelligence has long wanted an operation to be launched on us. A delegation was sent to Turkey in this regard. This request was conveyed to President Recep Tayyip Erdoğan during his recent visit to the UK.'

As of the date of this publication, Adnan Oktar was still in prison and one of his 'most senior kittens' has agreed to cooperate with prosecutors in a plea deal.

Heroes and Villains

History is not connected with events, but with processes. Processes are things which do not begin and do not end but turn into one another ... There are in history, no beginnings and no ending.
R.G Collingwood

I was in Turkey to reclaim some semblance of normalcy after months of operations and rehab following a near fatal accident caused by an explosion while working in Libya. A friend's offer of a flat in downtown Istanbul was the lifeline I needed.

In Istanbul, some friends offered to help me get on the set of a popular Turkish TV soap opera. During my time working in the Arab world, I had long been fascinated by these extravagant shows—adored everywhere from the Balkans to Indonesia. I was only supposed to shoot one day, but ended up staying for nearly two years. I revelled in my new-found ability to film inside homes—in living rooms and bedrooms. I was able to photograph women in situations that had always been off-limits to me. I was getting to know a country through its drama and fictional storylines instead of its conflicts. I was changing as a photographer too—immersing myself in a version of reality; a parallel state of mind. I found a new way to relate to the medium I loved by spending time in a fictitious world, full of fantasy and drama.

But as the years passed, events turned darker and Turkey itself began to resemble a horror movie. The country was consumed with violence: fighting in the east, the rise of ISIS, the refugee crisis, suicide bombings in airports and on the streets. Istanbul was no longer the city of dreams it once was, but a city of nightmares. Each month brought a seemingly bigger and uglier event than the one before.

During this time, I began collecting movie posters as I moved around the country. Some came from bookshops, some from markets and other times friends would tip me off about a particular rare poster owned by a friend of a friend.

The movies in these posters were all made in the late 1970s and 80s—a period in which Turkey lurched from a political crisis to a military coup, to a purge and back into a political crisis. It was also a time when the country was wrestling with its own identity; was it secular? Was it left wing, was it right wing? Was it conservative? Was it a democracy? The movies reflected that quest for meaning. Often they were crass, low budget re-makes of Hollywood or Italian films. Action heroes, in the style of Sylvester Stallone, got a Turkish version, in the name of square jawed Cüneyt Arkin who saved Turkish cities from marauding terrorists and coup-plotting generals.

When looking at the current culture and politics of Turkey, the content of the posters was remarkable. The 1970s were a salacious time for world cinema and Turkey was no exception. A coup by Turkey's military in the autumn of 1980 didn't quite put an end to the risqué and erotic films that were being produced on Yeşilçam Street, but the subsequent crackdown of leftists and liberals certainly dented the output. Though the censorship put in place by the new military rulers was relatively tolerant of soft porn, it was far less lenient to anyone who dared create politically driven entertainment.

Outside of the film industry, during the 1980s, a new wave of liberal feminism arrived in Turkey reclaiming women's sexual identities and desires outside the family home. Even so, it's hard to look at these movies and see a correlation—women in Turkey clearly had a long way to go until their films showed more nuanced female characters: the victim, the siren, the arm candy, the mistress. Conservative, pious women were not represented.

As I stood alongside a tank the day after a failed military coup in July 2016 and watched my twitter feed replay CCTV footage of helicopter gunships strafe and bomb civilians in the nation's capital, the analogy between Hollywood fiction and reality was all too apparent. I took a walk the following afternoon to one of my favourite booksellers and passed municipality workers setting up for a 'demokrasi' festival—erecting huge soundstages and outdoor cinema screens to display mobile phone footage of the 'heroic patriots' who stood up to tanks the previous night.

I rifled through the bookseller's second hand selection, my attention turned to some dust-covered boxes of Yeşilçam Street movie posters. My eye caught the rugged, thousand-yard stare of Cüneyt Arkin—shotgun in hand, standing up to men in uniform. The scene depicted paratroopers falling from the sky, helicopter gunships, mushroom clouds of explosions and tanks marauding through the streets. As I got out my wallet to pay, the bookseller pursed his lips and tutted while pointing to the illustration of Cüneyt Arkin. 'That's not Cüneyt Arkin,' he said, 'that is Tayyip Erdoğan.'

Acknowledgements

This project, not one shred of it, would have been made without the unwavering support and love from my wife Polly. Your ideas, your guidance and your belief in the project and me, were steadfast when mine were not. I owe you so, so much. To my daughter Agnes Ula and to my son, Wilfred. I can only hope in the years to come, that this book makes sense to you in the post truth world that you have been unwittingly born into.

The Parallel State was kindly supported over the years by The Magnum Foundation, The Saint-Brieuc Photoreporter Festival, The Project Launch Award at Centre Santa Fe, Viewbook Transformations, World Press Photo Foundation, and The Aftermath Project.

This book would not have been made without the generous financial support of the Incite Project and Kingston Upon Thames University.

To my parents Karen and Pete for the love and understanding you have given during this time and all those other times before.

To Piotr Zalewski for the incredible essay but also the love when events did not go to plan. Pelin Turgut for contributing so beautifully and listening to my crazy ideas. Christian Felland, Has Avrat and the staff at Bellingcat.com for the immense work that went into deciphering and translating the WhatsApp messages.

Julian Rodriguez for your honest critiques and brutal editing, Claudine Boeglin for pushing the project into unchartered waters, Isabella Brancolini and Elizabeth Briener for the opening of doors I would never have gone down. To Constanze Letsch and Martin Selsøe Sørrenson for walking me down some of Turkey's finest back alleys. To Jonathan Lewis for granting me the keys to the Faik Pasa front door. Owen Matthews for early Istanbul familiarisations and connections, Irmak Yazin, Recai Karadonoz, Özlem Özsümbül and all the producers, directors, camera operators at KanalD for allowing me to wonder aimlessly on your sets and locations. To Angel Boran for your bravery, awareness and ability to call bullshit. Jason Eskenazi for exhibiting the work in Istanbul and your metal board editing nights. Andrew Gardner and the staff at Amnesty International. To Ken Grant and Clive Landen for setting me on the right path.

Monica Allende, Jessica Murray, Donald Weber, Guy Tillim, Carolyn Drake, Ivor Prickett, Mathias Depardon, Emin Ösmen, Chloe Kerlaus, Alrik Swagerman, Rebecca Simmons, Max Pinckers, Anastasia Taylor-Lind, Andrea Kurland and the staff at *HUCK*, Robin Hammond, Ahmet Unver and Anne-Mette Møller, Julie Upmeyer, Marina Paulenka, Josh Lustig, Emma Bowkett, Harry Hardy, Adrian Evans and the staff at Panos, George Georgiou and Vanessa Winship for early editing guidance, Mark Lubell and the staff at ICP, Susan Meiselas, Emma Raynes, Lina Pallotta, Teresa Bellina, Mark Power, Marco Pinna, Q. Sakamaki, Sarah Leen, Simone Sapienza, Ayla Jean Yackley, Can Dündar, Clinton Cargill, Diana Suryakusuma, Paul Moakley, Stacey Clarkson, Lucy Conticello, Lauren Heinz, Cathy Remy, Francesca Sears, Olivier C. Laurent, Gaia Tripoli, Hideko Kataoka, Ilan Godfrey, Katja Magnusson, Rena Effendi, Zack Canepari, Ghaith Abdul Ahad, Mal Stone, Stephen Mayes, Tom Jamieson for the pizza, spare room and youthful guidance. To Tristan Lund and Harriet Logan I'm eternally grateful.

Stu Smith, Claudia Paladini and the staff at GOST for the beautiful design, production and patience with this project.

Finally to Chris Hondros and Tim Hetherington, whom I miss dearly and think about every day.

First published in 2018 by
GOST Books
8a West Smithfield
London
EC1A 9JR
info@gostbooks.com
gostbooks.com

Edited and designed by GOST:
Katie Clifford, Gemma Gerhard, Allon Kaye,
Claudia Paladini, Ana Rocha, Justine Schuster

Printed in Italy by EBS.

British Library cataloguing-in-publication data.
A catalogue record of this book is available from
the British Library.

ISBN 978–1–910401–22–4

THE INCITE PROJECT

panos pictures